Gods and Generals

Photographic Companion

Glass Plate Images by
Photographer Rob Gibson

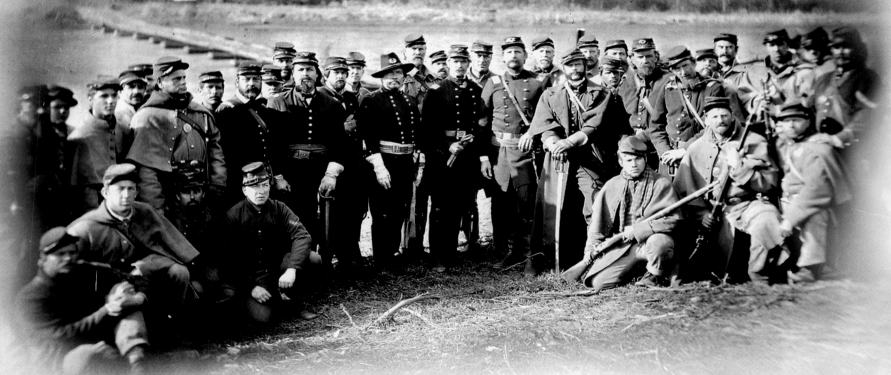

Foreword by Ron Maxwell

Thomas Publications
Gettysburg, Pa. 17325

Text by Dennis E. Frye

SPIRITS

In great deeds something abides. On great fields something stays.... Spirits linger, to consecrate ground for the vision place of souls. And reverent men and women from afar, and generations that know us not and that we know not of, heart-drawn to see where and by whom great things were suffered and done for them, shall come to this deathless field, to ponder and dream; and lo! The shadow of a mighty presence shall wrap them in its bosom, and the power of the vision pass into their souls.

— Joshua Lawrence Chamberlain

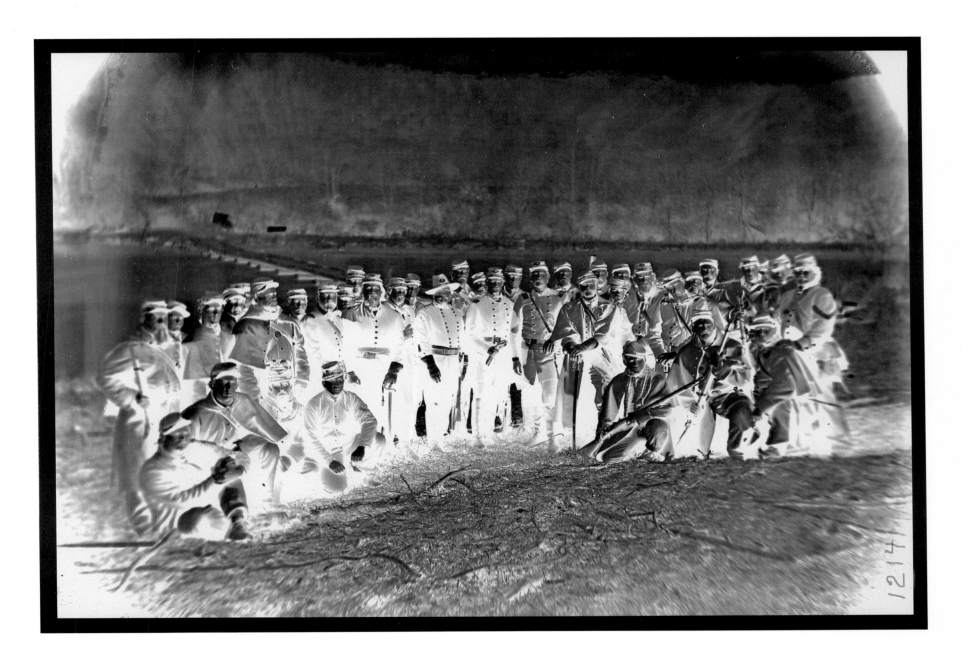

Gods and Generals

Photographic Companion

Dedications...

to my father Robert Gibson Sr. and my departed mother Frances,
for always believing in me.

— Rob Gibson

To the nearly 3,000 reenactors who volunteered to participate in the making of
Gods and Generals. I salute you for your knowledge, your skills, and your
passion to present and preserve history.

— Dennis E. Frye

Contents

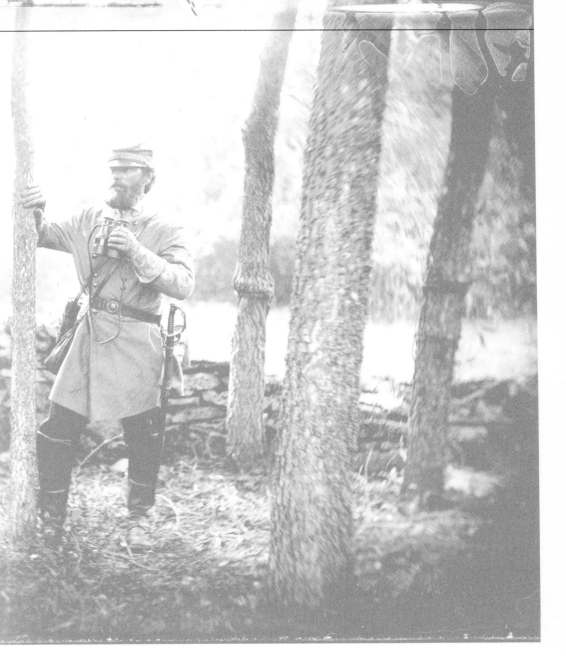

Acknowledgments

The Civil War was a perfect opportunity for photographers to capture scenes that will be forever etched in American history. An epic film such as *Gods and Generals* presented me with the same opportunity.

Without the help of so many, a book like this would never be possible. First I would like to thank Director Ron Maxwell for allowing me to be a part of this wonderful production. Ron's dedication and commitment to excellence was truly an inspiration. I would also like to thank Ted Turner Pictures along with Warner Brothers and all their producers for bringing this great story to the screen. Thanks to Dennis Frye, whose intimate relationship with the film as associate producer, and background as a historian made him the perfect choice to write the accompanying text. Thanks as well to Dean, Sally, and Jim Thomas, Andy DeCusati, Truman and Kay Eyler of Thomas Publications in Gettysburg. Hurrah! to Keith Baumbach and Icon Graphics for their splendid design work. We also appreciate the constructive comments of Sylvia Frye. All had a hand in producing this attractive book. Special thanks goes to Vic Heutschy, publicist for the film. Had it not been for Vic's confidence in me and my work I would never have had access to the set or the actors. Thanks to Van Redin, still photographer for the film, and all the cast and crew, and to my personal staff including Fred Ewers, Scott Burgard, Robert Bosler, Brian Merrick, and Kevin Rawlings. Special thanks go to Don Aros.

The following individuals were of great help or encouragent along the way: Robert Duvall, Stephen Lang, Jeff Daniels, Bo Brinkman, David Carpenter, C. Thomas Howell, Bruce Boxleitner, Brian Mallon, Mac Butler, Royce Applegate, Buck Taylor, Bob Dylan, Jeff Shaara, William A. Frassanito, Ken Burns, Brian Pohanka, Rob and Rebecca Dalassandro, Ross Kelbaugh, Mary Panzer, Pat Falci, Keith Gibson, Bob Zeller, Gabor Boritt, Kees Van Oostrum, Jon Muller, Michael Atland, Mike Wicklein and his crew, Steven Halbert, Cynthia Baggstrom, Kelly Farrah, Dr. Ray Giron, John Bert, Dana Heim, Don Warlick, Mark and France Osterman, Ray Davenport, Sheryl Miller, Jim Tennison, Brad Graham, Craig Haffner, Kevin Hershberger, John Coffer, Ray Morganwick, Bill Dunaway, Claude Levet, Oliver Morris, Dennis Brack, Allan Geoffrion, Donna Abraham, Chuck Morrengiello, Garry Adelman, Tim Smith, Nick Buxey and the late Al Benson.

Foreword

More books have been written about the Civil War than any other period in American history. But none are like this one.

The *Gods and Generals Photographic Companion* truly is unique. Through the use of original glass plate photography methods, this book captures the essence of the era. The striking poses and the stunning reality – even though photographed in the twenty-first century – along with the graceful prose and poetry of the text, will easily transport the reader into the middle of the nineteenth century.

I first began working on the movie *Gods and Generals* nearly ten years ago. With the success of *Gettysburg*, I knew we could share more of the story on the big screen. My good friend Jeff Shaara began researching the early years of the war, and his endeavors and his talents produced his best-selling historical novel, *Gods and Generals*. I now could pursue a prequel to *Gettysburg*, and through the generosity of Ted Turner and Ted Turner Pictures, the movie *Gods and Generals* is a reality.

Rob Gibson's and Dennis Frye's partnership on *Gods and Generals Photographic Companion* has produced a superb volume that complements the characters and the story presented in the film.

Rob's knowledge of Civil War wet plate photography is unsurpassed. Through use of an original period camera, he employs the methods of the pioneers in this field – and the results are spellbinding. Gibson's photographs eerily appear like original 1860s images. In fact, the quality is so good, and the images so realistic, it is difficult for an observer to differentiate between a period photograph and a Gibson image. In addition to Rob's technical skills, he also is an accomplished artist. Gibson understands that photography *is* art, and in the case of wet plate photography, challenging art. But look at the eyes. Study the faces. Examine the poses. Reflect on the landscapes. These are the pictures of an artist.

Surprisingly, Gibson's photography assisted us in the production of the film. Fascinated by the process – and even more impressed with their pictures – our cast members queued up to have their costumed images captured on glass plates. Rob's photographs became a veritable "portal to the past" for both cast and reenactors, and this helped establish a period "tone" for my work as a film maker.

The photographs attract one's attention, but by themselves, they tell no story. My close friend Dennis Frye breathes life into every photograph through his enlightening and lively text. Dennis, who served as my associate producer, is a renowned Civil War historian and former Chief Historian at Harpers Ferry National Historical Park. He understands that history is people, not dates. He appreciates history, not as facts, but as humans relating to other humans, whose experiences and decisions direct the future. Dennis's humanistic approach to history is revealed by the dramatic quotations he has discovered and woven throughout the book –words of actual participants which bring immediacy to events that occurred 140 years ago. Frye also shares some of the poetry and music verse from the period, which is so rich and so prevalent, and this further humanizes the people of the past.

I first read Michael Shaara's Killer Angels 25 years ago. What started out as a good read over a few hours has turned into a life's work. The Civil War is an eternal story – an eternal human story. It distinguishes us as a people. It forged this nation and its people. Gods and Generals Photograhic Companion helps tell our story.

— Ron Maxwell

Introduction to Wet Plate Photography

By Rob Gibson

By the 1860s, photography was more than 20 years old. New innovations and techniques were constantly being announced. The wet plate process was the format of choice, replacing the antiquated daguerreotype process. Photographs could now be printed on paper and mass produced from a single glass plate negative.

With the outbreak of the Civil War, the timing could not have been better. Photography had gone from a magical curiosity to a medium that was able to record history and distribute it quickly to an eager public, one that was both horrified and yet fascinated with what they saw. That fascination is still with us.

Arguably, the greatest reason why so many are intrigued by the American Civil War is because of the powerful legacy left to us by the photographic pioneers of the time. I remember as a teenager poring over volume after volume of *Miller's Photographic History of the Civil War*, hoping to get a glimpse of my great grandfather and his father, both members of the New York 2nd Mounted Rifles.

In later years while doing research I discovered a book that would forever change my life, *Gettysburg: A Journey in Time* by William A. Frassanito. The same images I had seen as a teenager were now presented as historical documents, thoroughly researched and reproduced more detailed than ever. In the background of a few obscure images was the photographer's darkroom wagon. I was fascinated and determined to learn more.

Getting some help from the International Museum of Photography in Rochester, New York, my skills improved. I found myself invited to demonstrate at the Smithsonian's National Portrait Gallery where I met Bob Zeller, author of the book *The Civil War in Depth*. Together we lectured at the National Archives and on C-Span. I was later invited to demonstrate for the White House Press Photographers Association. It was then that I realized that I could make a living doing something I loved. I left my job as an engineer in Rochester and headed for the mecca of the Civil War world, Gettysburg, Pennsylvania.

Gibson's Photographic Gallery opened its doors in May 1999 and is the world's only full time wet plate studio. Thousands of visitors have been photographed by a process long forgotten with cameras that belong in a museum.

My large studio camera dates back over a hundred and thirty years. Its lens bears the name Richard Walzl, a Baltimore photographer famous for photographing Confederate officers and dignitaries. While selling these images from his studio, Walzl was imprisoned for disloyalty. He was eventually released; however he still continued to sell Confederate photos, taking his name off the backmark.

A famous photograph exists of Confederate President Jefferson Davis bearing no backmark. Many believe it was taken by Walzl.

It is only fitting that Robert Duvall, portraying Confederate General Robert E. Lee, was photographed with the same lens.

14

Mind of a Chemist, Eye of an Artist, Patience of a Saint

Here are the basic steps of the wet plate photography process. There are a number of books giving details to the formulas and techniques. One of the best is from the George Eastman House.

Step 1 Cleaning the Plate.

The glass plate must be meticulously cleaned and must be free of any dirt and oil.

Step 2 Flowing the Plate.

The plate is coated with a sticky substance called collodion. It is a mixture of nitrocellulose and ether. Alcohol iodides and bromides are added. Getting good at flowing the plate takes years of practice and is an art in itself.

Step 3 Sensitizing the plate.

The plate is immersed in a bath of silver nitrate. This must be done in a darkroom.

Step 4 Focusing the Camera.

The camera is focused by adjusting a focusing glass on the back of the camera. The image is projected upside down and backward on the focusing glass. The photographer crawls under the dark cloth to view the image. He must make certain the camera and the subject do not move while he retrieves the plate.

Step 5 Exposing the Plate.

The plate is placed in a light proof plate holder while still in the darkroom. Next it is rushed to the camera. The focusing glass is removed and the plate holder is inserted in its place. The exposure is made by removing the lens cap and counting. Exposure times for images in this book ranged from two seconds to ten seconds. There are no light meters; experience and instinct are your only guides.

Step 6 Developing the Plate.

Back in the darkroom the plate is developed using a solution of iron sulfate, acetic acid and grain alcohol. The photographer has only 3-5 minutes from the time he removes the plate from the silver bath until the plate is developed before the plate "dries out" and is no longer light sensitive. Thus the name "wet plate" process.

Step 7 Fixing the Plate.

The plate is fixed in a solution of potassium cyanide or sodium triosulphate. This can be done out of the darkroom.

Step 8 Varnishing the Plate.

The glass plate is finally ready to be varnished after it is dried. This will protect the image from scratches and deterioration over time. When all these steps are done correctly the image can last hundreds of years.

While viewing the photographs in this book, keep in mind that most images are unique; there was no time for reshoots given the tight filming schedule. Motion was out of the question — any movement was a blur on the plate. All plates were processed in a portable darkroom tent in the field. At times the chemicals froze or boiled off the plate due to extreme conditions, and there were some missed opportunities, just as there were during the real Civil War.

Historical Overview

Abraham Lincoln's election in 1860 drove a stake into the heart of the old Union. Southerners considered Lincoln and his fledgling Republicans as anti-slavery. With the Republicans controlling the White House and both branches of Congress, disenfranchised Southerners believed their entreaties were meaningless and their rights were in peril. Lincoln assured them otherwise, but his overtures of cooperation and peace found few listeners in the threatened South.

On December 20, 1860, only six weeks after Lincoln's election, the state of South Carolina seceded from the Union. By February, Mississippi, Florida, Alabama, Georgia, Louisiana, and Texas had removed their stars from the Union flag. A new country was formed — the Confederate States of America — with a new capital established at Montgomery, Alabama, and a new president, Jefferson Davis, elected.

The more moderate Upper South did not depart the Union as quickly. Efforts at compromise were underway, and Upper South secession conventions were packed with pro-Union delegates. All eyes focused upon Virginia, which counseled negotiation and patience. As the most populous state in the South, and the oldest as well, Virginia had provided the country with six presidents. Its position was paramount to peace, and its direction could determine the future of both North and South.

Peace suddenly evaporated on April 12, 1861, when Southern shells shattered the morning air in Charleston Harbor, South Carolina. Confederate forces began bombarding the Federals defending Fort Sumter, and with its surrender, the South earned its first military triumph. But President Lincoln could not permit this flagrant assault against a United States fort and United States soldiers. Subsequently, three days later, Lincoln called for 75,000 volunteers to end the rebellion in the seceded states. There was no choice but war.

Virginia objected. She would not send her men to invade the soil of her Southern sisters. Virginia, instead, seceded and joined them. The Old Dominion offered Richmond as the capital of the Confederacy; and it offered Robert E. Lee — a distinguished and veteran United States army officer — command of its military forces.

Within days, Virginia found itself preparing for war. At Harpers Ferry and Manassas Junction, as well as other points of defense, General Lee established garrisons to protect the Commonwealth's interests. Thousands of exuberant militiamen swarmed to these strategic positions, offering their services to their new country. Veteran officers soon commanded these posts, including Colonel Thomas Jonathan Jackson at Harpers Ferry. During the next three months, officers marched and drilled their men as they attempted to transform civilians into an army of soldiers.

Meanwhile, tens of thousands had rallied behind the Stars and Stripes. They came flocking to Washington to defeat the Southern foe, who had dared to fire upon their flag. By mid-July, the Union army was marching upon Manassas Junction, certain it was "On to Richmond" from there. But the Confederates blocked the road on

July 21, 1861, as the brigade of Thomas J. Jackson stood "like a stone wall." The bloody battle ended in an embarrassing Federal rout, and illusions of a short, bloodless war, soon evaporated.

As both sides evaluated their war strategies, Union authorities developed a comprehensive plan. Named "Anaconda," after the snake that squeezes and strangles, the Federals would use their armies to invade the South from Missouri to Arkansas to Tennessee to Virginia. They also would blockade Southern ports and capture key posts on, and reassert control over, the Mississippi River. But despite this long-range plan, U.S. authorities continued to focus on Richmond, believing that the loss of the Confederate capital would doom the Southern nation.

Virginia thus became a battleground. In the early spring of 1862, Union armies launched invasions into the Shenandoah Valley and onto the peninsula between the James and York rivers — a heralded new approach toward Richmond. Both expeditions failed. Stonewall Jackson defeated three separate armies in the Valley, and Robert E. Lee crushed the Union offensive in seven days of vicious fighting about Richmond.

With the Union armies reeling backwards, Lee then moved north, defeating another Federal force at Second Manassas in late August 1862, and then launching an invasion into Maryland in September. The Confederate momentum then deflated when the invasion prematurely ended with Lee's retreat from Antietam. This long-sought Northern victory enabled President Lincoln to issue the Preliminary Emancipation Proclamation, changing the

war from a mission of preserving the Union to one of Union and freedom.

Then the war returned to Virginia. Another "On to Richmond" campaign commenced, but this time Lee thwarted the enemy's advance at Fredericksburg on December 13, 1862. The new year brought a respite in the fighting, but when spring arrived, yet another Federal offensive began. At Chancellorsville during the first week of May 1863, Lee faced overwhelming odds and a dangerous opponent. Through risk and resolve, Lee attained his greatest victory, but at a great loss — Stonewall Jackson would fight no more battles for the Confederacy.

Following Lee's triumph at Chancellorsville, the Confederate army once again invaded the North. This time the Southerners entered Pennsylvania, and during the first three days of July at Gettysburg, two nations faced their destinies. Lee lost. He suffered his greatest defeat, and the future of the Confederacy became in doubt.

The war dragged on for nearly two more years after Gettysburg. Lee would have other victories, but elsewhere, Union armies conquered mile after mile of Confederate territory. Lee himself was pushed into the defenses of Petersburg and Richmond, and after nine months of siege warfare, the armies of Ulysses S. Grant finally prevailed.

Nearly four years after Virginia's secession — with the blood of hundreds of thousands of killed and maimed soaking her soil — peace finally returned, on Palm Sunday, at Appomattox Court House, on April 9, 1865.

With all my Devotion

What should he do? His country was tearing apart. His loyalties were battling themselves. His patriotism was challenging his motives. His mind was combating his soul.

Robert E. Lee faced a tortuous decision—remain with the United States? Or adhere to his native state Virginia?

It could no longer be both. Virginia had seceded from the Union. She no longer claimed membership within the United States. The state that offered the country Washington, Jefferson, Madison, and Monroe, now cast its future with a new country—the Confederate States of America. Lee knew he must decide. "In my own person," he wrote his sister, "I had to meet the question."

The meeting that forced the question occurred soon enough. Francis P. Blair, Sr., a friend of Colonel Lee's, and an emissary of President Lincoln's, invited Lee into Washington. On the morning of April 18, 1861, less than twenty four hours after Virginia's secession vote, Lee departed his home at Arlington, rode across the Potomac bridge, and entered the capital. As he crossed the river, he literally passed from one country into another.

When Lee arrived at Blair's house on Pennsylvania Avenue, directly opposite the State, War, and Navy Building, the two men went behind closed doors. Blair announced his purpose. President Lincoln was offering him command of an army of 75,000, perhaps 100,000 men—and rank as a major general. His job would be to enforce federal laws and end the rebellion in the secession states. Lee had the best credentials. Second in his class at West Point, an experienced engineer, a Mexican War hero, superintendent at West Point, captor of the violent abolitionist John Brown at Harpers Ferry, and thirty six years of army experience—Lee was best suited to lead the United States Army.

As Blair ended his discourse, Lee sat silently. Then, he stiffened in his dress blue uniform and responded, firmly and without equivocation: "If the Union is dissolved and the government disrupted, I shall return to my native state and share the miseries of my people and save in defense will draw my sword on none."

Lee later recalled this most fateful moment: "I declined the offer...stating as candidly and as courteously as I could, that though opposed to secession and deprecating war, I could take no part in an invasion of the Southern States."

His struggle was over...and just beginning.

> [N]o man [is] his superior in all that constitutes the soldier and the gentleman-no man more worthy to head our forces and lead our army. There is no man who would command more of the confidence of the people of Virginia
>
> — The Alexandria *Gazette*, April 20, 1861

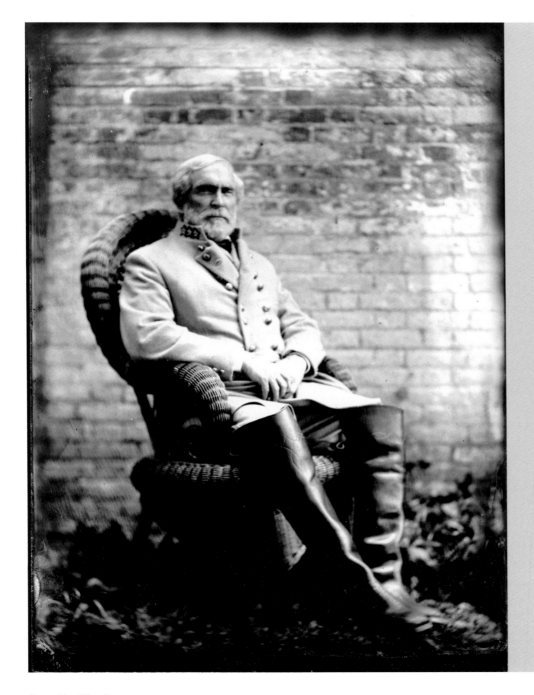

My husband has wept tears of blood over this terrible war, but as a man of honor and a Virginian, he must follow the destiny of his state.
— Mrs. Mary Custis Lee

With all my devotion to the Union and the feeling of loyalty and duty of an American citizen, I have not been able to make up my mind to raise my hand against my relatives, my children, my home.
— R. E. Lee, letter to his sister, April 20, 1861

Robert Edward Lee, portrayed by Robert Duvall.

Secession

Virginia Joins the Confederacy

The election of Abraham Lincoln created a furor throughout the South. Convinced that Lincoln and his Republican Party represented a threat to slavery and states' rights, South Carolina seceded from the Union on December 20, 1860. Within two months, six other deep South states had seceded, and a new nation had been formed—the Confederacy.

Virginia, the oldest and most populous state in the South, refused initially to join her Southern sisters. Most Virginians agreed with Robert E. Lee, who declared, "Secession is nothing but revolution," and who envisioned..."no greater calamity for the country than a dissolution of the Union."

Sentiments changed rapidly, however, following the Confederate bombardment of Fort Sumter in Charleston Harbor, South Carolina, on April 12, 1861, and President Lincoln's call for 75,000 volunteers to end the rebellion. "Your object is to subjugate the Southern States," responded an angry Virginia Governor John Letcher to Lincoln's appeal, "and a requisition made upon me for such an object...will not be complied with. You have chosen to inaugurate civil war...."

By a vote of 88-55, the Virginia Secession Convention decided upon disunion on April 17, 1861. The Old Dominion soon would become the primary battleground in the South's war for independence.

A Union that can only be maintained by swords and bayonets, and in which strife and civil war are to take the place of brotherly love and kindness, has no charm for me.

— R. E. Lee, January 23, 1861

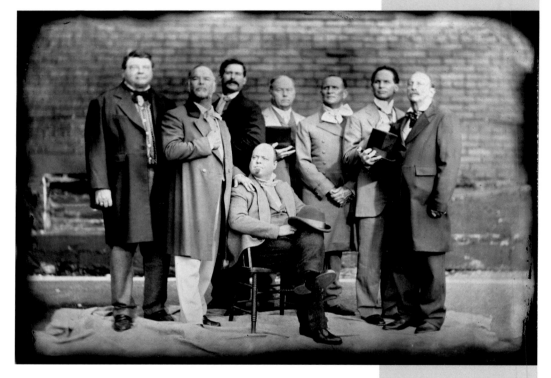

Members of the Virginia Secession Convention. Most of these men are present-day elected officials, invited by Dennis Frye to appear as "politicians" in the scene where Lee is offered command of Virginia forces. From right to left: Delegate John Doyle, representing Jefferson County, West Virginia, where the scene was filmed; Commissioner Greg Snook and former Commissioner Ron Bowers, who voted to authorize local funds to bring the movie to Washington County, Maryland; Senator Don Munson and Delegate Chris Shank, whose districts in Maryland offered sites for much of the filming; and seated, Delegate John Donoghue, representing Hagerstown, the county seat of Washington County.

Politicians' Play

John Janney, a pro-Union delegate from Loudoun County, Virginia, remained a staunch Unionist until after the firing on Fort Sumter and President Lincoln's subsequent call for Virginia troops to help squelch the rebellion.

John Janney (Robert Easton), President of the Virginia Secession Convention

Mr. President, and Gentlemen of the Convention—Profoundly impressed with the solemnity of the occasion, for which I must say I was not prepared, I accept the position assigned me by your partiality. I would have much preferred had your choice fallen on an abler man. Trusting in Almighty God, an approving conscience, and the aid of my fellow-citizens, I devote myself to the service of my native State, in whose behalf alone will I ever again draw my sword.

— R. E. Lee, on his appointment as commander of Virginia forces, April 23, 1861

Phil Gramm, former United States Senator from Texas, portraying a delegate to the Virginia Secession Convention, and boasting the best mutton chops in the movie. Senator Gramm heartily cheered the appointment of R. E. Lee.

And now, Virginia having taken her position, as far as the power of this Convention extends, we stand animated by one impulse, governed by one desire and one determination, and that is that she shall be defended; and that no spot of her soil shall be polluted by the foot of an invader.

— John Janney, in his introduction of R. E. Lee, April 23, 1861

School of Leaders – Virginia Military Institute

No school in the South produced so many Confederate officers as the Virginia Military Institute. Yet unlike West Point, VMI was not established to train professional officers. Its mission, instead, was to prepare students for leadership roles in civilian life. The school's rigorous military system helped develop and mature those leadership abilities. When war did erupt, however, the knowledge and experience of VMI graduates and cadets initially helped Virginia's Confederate armies win victory after victory.

The Institute and its military tradition, established in 1839, attracted Thomas Jonathan Jackson to Lexington. Here he began serving as a professor of natural philosophy (physics) and an instructor of artillery in 1851. Jackson, who himself was a graduate of West Point, a Mexican War hero, and a career army officer, knew little about teaching, and even less about physics. Yet Jackson determined to prevail: "I am anxious to devote myself to study until I shall become master of my profession."

Jackson's exacting discipline and his tortuous classroom lessons endeared him to few cadets. "No one recalls a smile, a humorous speech, anything from him while at [VMI]," remembered one cadet. "He was not sullen, or gloomy, or particularly dull. He was simply a silent, unobtrusive man, doing his duty in an unentertaining way—merely an automaton."

Jackson did percolate on the artillery drill field, for artillery was his passion and his previous profession in the army. "Tom Fool" and "Old Jack" became a model soldier for the young men when training about the guns, and their respect for him as a soldier drew high estimation.

Many cadets became temporary soldiers in the aftermath of abolitionist John Brown's failed assault against slavery at Harpers Ferry in the fall of 1859. Concerned that attempts would be made to rescue Brown from the scaffold, the cadets—including Jackson and two cannon—joined nearly 1,500 Virginia militiamen at Charles Town for the execution on December 2, 1859.

During the next sixteen months, war fever increased as Lincoln's election and the establishment of the Southern Confederacy sent Virginia hurtling toward secession.

Three days after the Old Dominion departed the Union, VMI cadets were on their way to Richmond to assist with the drilling of raw recruits. Leading the procession was Major Jackson, who at precisely 1:00 p.m. on April 17, 1861, barked "By file left! March!" Jackson had issued his first orders of the Civil War.

Service Defined

1,827 VMI alumni served in some capacity during the Civil War (nearly 95% of those alive). This included three major generals, fifteen brigadiers, 91 colonels, 65 lieutenant colonels, 83 majors, 259 captains, 331 lieutenants, and 100 sergeants. Their superior service also produced staggering losses. At least 171 alumni were killed or mortally wounded, and at least 60 more died from disease. The wounded toll was even more incomprehensible at 435. An additional 326 were captured.

Remember, each number represents a man—in most cases a very young man.

Virtually every infantry and cavalry battalion and regiment that Virginia raised for her defense and many of her artillery companies included a small cadre or nucleus of men who had passed through at least basic military training at the school in Lexington.

— Richard McMurry, VMI alumnus & Civil War historian

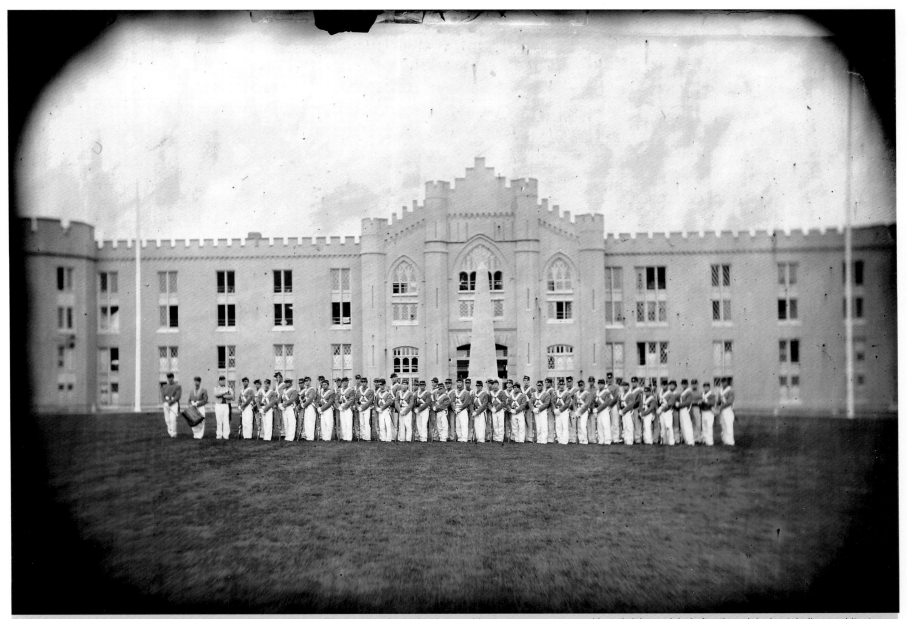

Cadets on the parade grounds of the Virginia Military Institute. The barracks in the background is a postwar structure, although it is modeled after the original antebellum architecture. VMI was burned in June 1864, by Union forces under Major General David Hunter. Note the obelisk in the center of the image. This was constructed by the film company to disguise the statue of Stonewall Jackson standing today at this location.

Give the Glory to God

His life did not begin with ease. At age two, his father died. At age seven, he was orphaned. Hardships threatened young Thomas Jonathan Jackson almost daily, but from this exacting experience, Jackson learned discipline, determination, and devotion — traits which defined his character.

Jackson's career as a soldier began at age eighteen when he received an appointment to the U. S. Military Academy at West Point as a substitute for a dropout. Academics at the academy proved a considerable challenge for the Clarksburg, western Virginia native, as he had received little formal education and was "introverted, awkward, and lacking in social graces." A West Point friend recalled Jackson "under great disadvantage — others were trained at the start but his mind was still the unbroken colt, shying here, tottering there, and blundering where his companions already knew the difficulties of the ground."

Yet Jackson persevered. Guided by the maxim, "You may be whatever you resolve to be," cadet Jackson applied rigorous study habits to move from the lower third of his class to the upper third (17th out of 59) by the time of his graduation in 1846. His attention to detail and his dogmatic adherence to structure passed him through his junior year without one demerit — an exceptional achievement at West Point.

The United States was at war with Mexico when Jackson graduated, and as a first lieutenant in the artillery, he headed south of the Rio Grande. He received citations for gallantry at Contreras and Chapultepec, and at Chapultepec — while driving his guns into the face of the enemy — he escaped near death when a cannon ball rocketed between his legs.

While in Mexico, Jackson developed an interest in the Spanish language, but more important, he began a serious investigation into religion. Fascinated by the Catholicism that dominated in this region, Jackson experimented first with this belief, but he discovered his preference was for "a simpler form of faith and worship." As his army service continued at Fort Hamilton on Long Island, he was baptized into the Episcopal Church. But when he returned to Virginia in 1851 to begin his career as a professor at the Virginia Military Institute, Jackson chose the Presbyterian Church as his place of worship.

At Lexington, Jackson discovered his church. In the lovely hamlet at the base of the Blue Ridge, Jackson established a new home with new friends. The "Major" commenced a new career as a teacher; and as a bachelor, he began searching for a bride. His life was good. So much had changed since his childhood. God had provided him with new opportunities, and to God, he owed his all.

God was in all his thoughts.
— James Power Smith, Jackson staff officer

His patriotism was a duty to God. His obedience to the State that called him to the field was made clear and plain to him, as obedience to God. All soldierly duty was rendered as a service to his God.
— James Power Smith

By it Abide

I would not part with the Bible for countless universes.
— Thomas Jonathan Jackson

Thomas Carlyle said "A man's religion is the chief fact with regard to him." And more than any other man of renown of modern times, it is true of Jackson that his religion was the man himself. . . .

Eminent critics are telling us that the campaigns of Jackson will be the study and admiration of military schools for centuries to come. However true that may be . . . the religion of Stonewall Jackson will be the chief and most effective way into the secret springs of the character and career of this strange man, who as the years go by is rising into the ranks of the great soldier saints of history.

— James Power Smith, remarks at the dedication of Jackson Memorial Hall, Virginia Military Institute, 1893.

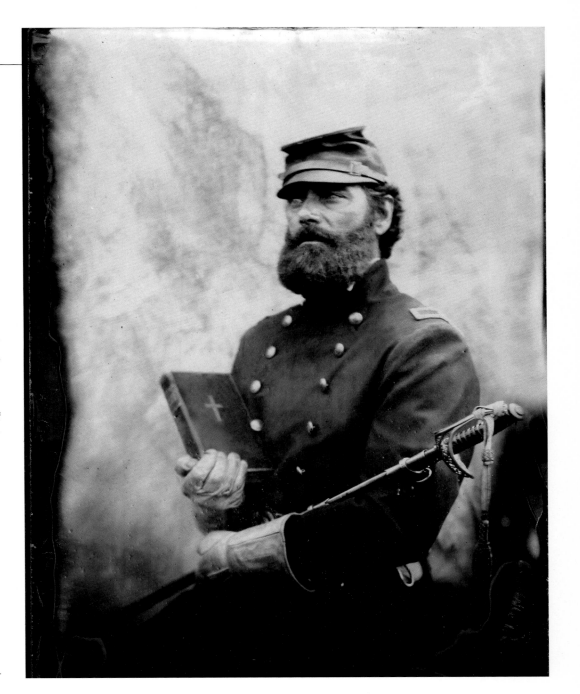

Thomas Jonathan Jackson, portrayed by Stephen Lang.

Volunteers

During the spring months of 1861, hundreds of militia companies and thousands of militiamen reported to designated muster locations in the North or positions of defense in the South. Harpers Ferry, Virginia, became a point of concentration at the mouth of the Shenandoah Valley, and the daily arrival of militia more than doubled the town's population in a week. The atmosphere at the Ferry and elsewhere was festive and almost carnival-like as these "civilian warriors" eagerly prepared to meet their fellow Americans on the field of battle. Almost none envisioned four years of violent bloodshed and hundreds of thousands of corpses.

I do not suppose that at anytime, before or since, was there ever such a collection of variegated uniform, so much tinsel, so many nodding plums, so long and so many sashes, cocked hats, jingling spurs and swords, or such resplendent dress parades as of the first week or two at Harpers Ferry.

— Charles Gratton, April 1861

Nothing was serious yet; everything was much like a joke.

— Henry Kyd Douglas, private, 2nd Virginia Infantry

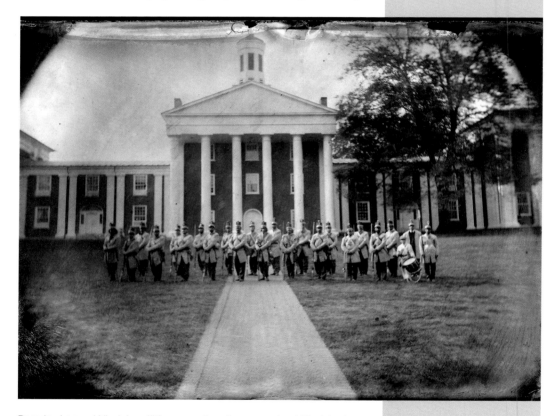

Parade-dressed Virginia militia arrayed on the grounds of Washington College in Lexington. Note the knee-length frock coats and the shako hats, characteristic of the plethora of uniform types throughout the South at the commencement of the war. After Appomattox, Robert E. Lee served as president of this institution, which was renamed Washington & Lee following his death here on October 12, 1870. General Lee and most members of his family are buried at the chapel bearing his name on this campus.

Triumph or Tomb?

No one knew how long it would last. No one expected it to last long. The war meant separation. Husbands separated from wives. Fathers separated from daughters. Sons separated from mothers. Although all understood that war could mean death, few acknowledged the reality of the grave. None envisioned the hardship, the horror, and the helplessness. When the war commenced, cheers and flowers and flags greeted the men departing the household. Soon, only letters, and a possible photograph, became the connection that tied the family together. With each passing day, while he was away, memories became stronger than flesh and breath.

We know not; in the temple of
the Fates
God has inscribed her doom:
And, all untroubled in her
faith, she waits
The triumph or the tomb.

— Henry Timrod

Civilians in Lexington, posing shortly after the VMI cadets marched off to war. Some thoughts were cheerful, but others foreboding, as they began life in a new country, the Confederacy.

Jackson's First Command

The Civil War commenced for Thomas Jonathan Jackson when he arrived at Harpers Ferry, Virginia (today West Virginia). Assigned his first field command at the picturesque confluence of the Potomac and Shenandoah rivers, Colonel Jackson arrived at the Ferry on April 30, 1861, less than two weeks after Virginia's secession. Attired in his VMI major's uniform, Old Jack did not make a good first impression. "The Old Dominion must be woefully deficient in military men if this was the best she could do," remarked one incredulous recruit.

But Jackson was more interested in business than appearance. He had a fledgling army of 8,000 men, but there was little organization, no general staff, no hospital or ordnance departments, outdated and failing flintlock muskets, and scarcely six rounds of ammunition to the man. Even worse, the enemy occupied Maryland, placing Harpers Ferry at risk of an early attack.

Jackson wasted no time. Seven hours of drill per day became the soldiers' primary occupation. Enforcement of the strictest military code became the top priority. Discipline and instruction replaced the pomp and circumstance of the defrocked militia. Defenses were established to fend off an enemy attack. Dismantling began of the priceless machinery at the U.S. armory, and then it was shipped south. "What a revolution three or four days had wrought," exclaimed one reformed rebel. "Perfect order reigned everywhere."

While at Harpers Ferry during the spring of 1861, Jackson organized the First Virginia Brigade, comprised of five infantry regiments that boasted nearly 3,500 volunteers from the Shenandoah Valley. Atop the pastured fields of Bolivar Heights, Jackson methodically trained and marched and molded these men—transforming them from farmers and teachers and carpenters into soldiers—soldiers that soon would stand in battle like stones in a wall.

Harpers Ferry and the Stones of the Wall
I am of the opinion that this place should be defended with the spirit which actuated the defenders of Thermopylae.

— Colonel Thomas J. Jackson, Harpers Ferry, May 7, 1861

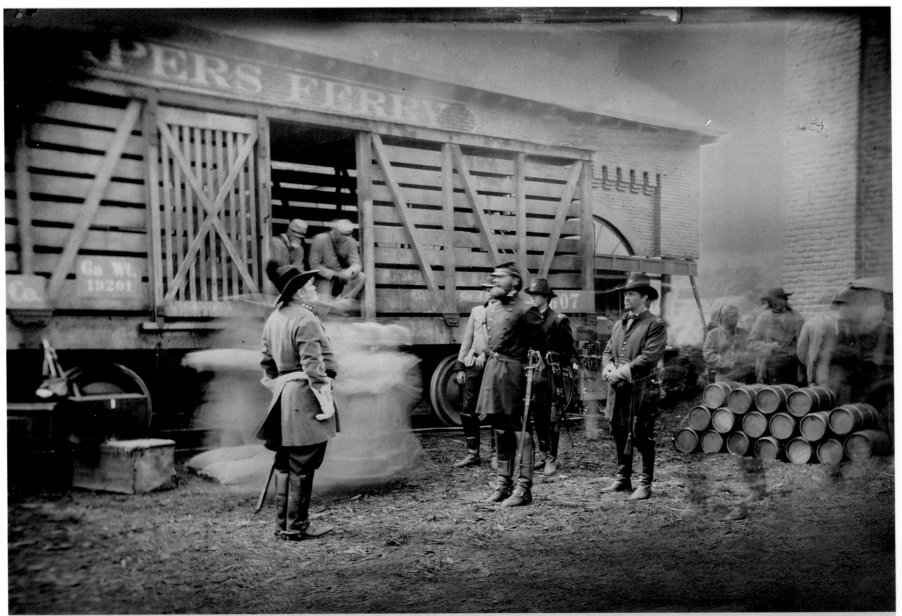

Colonel Jackson (Stephen Lang), center, facing left, addressing Colonel Isaac Ridgeway Trimble (Morgan Shepherd) adjacent to the Baltimore & Ohio Railroad and the United States armory grounds at Harpers Ferry. As commander at the Ferry, Jackson often stopped train traffic to ensure that no Union supplies or soldiers were passing through Southern territory. When the Confederates abandoned the Ferry on June 14, 1861, the B & O Railroad bridge crossing the Potomac River was blown up—the first of nine times it was destroyed during the war.

The Stonewall Brigade Earns its Name

"On to Richmond!" rang the chorus. The newspapers demanded action. Congress wanted to fight. The Lincoln Administration was growing impatient. The war must end, and end quickly. Capture of the Confederate capital at Richmond would embarrass the fledgling nation and help reassert Federal authority in the errant and seceded South. One battle — and the war would be over.

So reasoned authorities in Washington, D.C., as a Union army of 35,000 men — the largest army this country had ever seen-began advancing against the railroad junction of Manassas, Virginia, only thirty miles southwest of the capital. The Federal troops were well equipped and well uniformed, but they were not well trained. Only three months before, they were working at their farms or factories or desks. But never mind training, nor experience — "You are green, it is true," President Lincoln acknowledged to his commander, Irwin McDowell, "but they are green also." The Rebels will be rolled.

Meanwhile, blocking the road to Richmond stood a Confederate force of 22,000 defending Manassas Junction. Badly outnumbered, these Southerners were depending upon the ability of a second Confederate army to move swiftly from the Shenandoah Valley, some 50 miles distant, to even the odds. If the 11,000 men in Joseph Johnston's Valley force could join the Confederates at Manassas, the contesting armies nearly would be equal. But what a gamble! — Southern strategy depended upon a forced march. If Johnston arrived too late, the battle could be over, and Confederate defeat certain.

Thomas Jonathan Jackson and his First Virginia Brigade were resting with the Shenandoah Valley army near Winchester when word arrived. The Federals were driving against Manassas! The army must hurry and save the nation! Jackson's Brigade sprang forward, leading the way, marching all day on the 18th, and entraining on cattle cars on the Manassas Gap Railroad on the 19th. The brigade made history — for the first time

a military force was transported toward a field of battle via railroad. As a result, the Confederates won the race! The Southern armies united at Manassas. Would their good fortune carry over to the battlefield?

No. It did not appear so. The battle commenced on Sunday morning, July 21, 1861. A Union flanking column attempted to turn the Confederate left. Although the movement was discovered and resisted, there were too many Federals breaking the dam. The Southern lines collapsed, and soon 3,000 Rebels were racing rearward toward the heights of Henry Hill.

The moment for Jackson's First Virginia Brigade had arrived. Posted on the southeastern edge of Henry Hill, aligned behind thirteen Confederate cannon, defiantly stood Jackson's five regiments. Around them, chaos and confusion reigned as bewildered and defeated men from the morning fight continued to press to the rear. Witnessing this disorganized rabble, Brigadier General Bernard Bee spied Jackson's disciplined command. "Look, men, there is Jackson standing like a stone

wall!" he shouted. "Let us determine to die here, and we will conquer!" The words became immortal — but General Bee proved only too mortal — later in the day he was killed.

The "stone wall" quickly was tested. The Federals rolled twelve pieces of artillery to within 100 yards of the brigade, but the Virginians accepted the challenge, charging the guns and nearly destroying the Yankee batteries. Jackson's men held Henry Hill that Sunday afternoon, and Confederate reinforcements arrived to break the enemy offensive and send the Federals in a panicked rout toward Washington. The newly-christened "Stonewall Brigade" had turned the tide.

First Manassas. First fire. First blood. First death. The battle ended . . . but the war had just begun.

A terrible volley was poured into them. It was like a pack of Fourth of July fire-crackers under a barrel magnified a thousand times. The Rebels had crept upon them unawares and the batteries were all killed and wounded. . . .

All was confusion; wounded men with dripping wounds were clinging to caissons, to which were attached frightened and wounded horses. Horses attached to caissons rushed through the infantry ranks. I saw three horses galloping off, dragging a fourth, which was dead. The dead cannoneers lay with the rammers of the guns and the lanyards in their hands. The battery was annihilated by those volleys in a moment.

— Warren Lee Goss, a Federal private

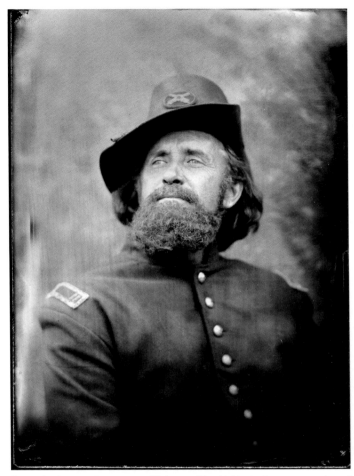

Captain James Brewerton Ricketts (David Foster), commander of Company I, 1st U.S. Artillery, assaulted by the Stonewall Brigade on Henry Hill. A West Point graduate and a career army artilleryman, he was shot four times and captured by the Confederates at First Manassas. He recovered from his wounds and was returned from captivity six months after the battle, and soon was promoted to a Union general. He survived the war, dying in 1887, and was buried in Arlington National Cemetery, the former home and estate of Robert E. Lee.

Our battery being demolished in that way was the beginning of our defeat at Bull Run.

— Warren Lee Goss, a Federal private

Federal artillery preparing for action at First Manassas. Union cannoneers in Ricketts' and Griffin's batteries were decimated on Henry Hill by the Stonewall Brigade. The Confederates captured eight of their twelve cannon; killed 16 cannoneers in close-order combat; wounded another 28, and captured 10 — nearly triple the total number of artillery losses for the rest of the Federal army.

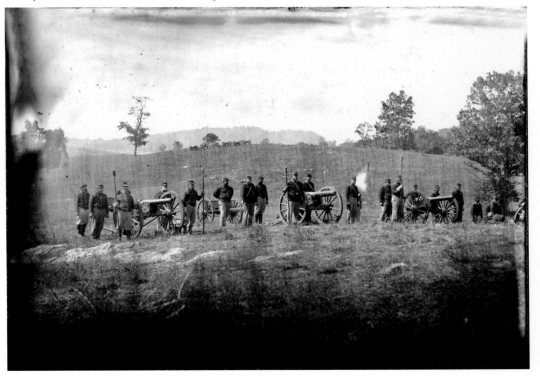

Standing like a Stonewall

Standing like a stonewall proved costly for Jackson's First Virginia Brigade. Initial reports revealed 111 killed, 368 wounded, and five missing. One of every three men in the 33rd Virginia was a casualty. The 2nd Virginia — in its very first action — suffered more killed and wounded than in any other battle of the war.

You must not be surprised to hear of me getting killed, for we don't know when we will be killed.

— John O. Casler, Stonewall Brigade, in a letter to his mother three days after the battle

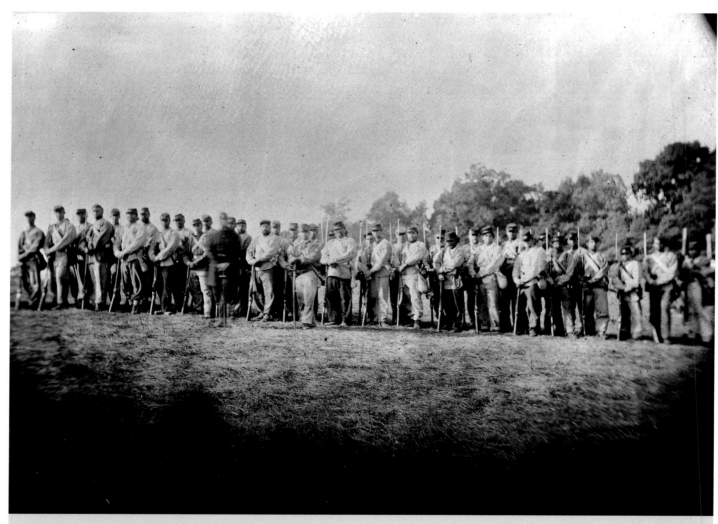

A company of the Liberty Hall Volunteers, 27th Virginia Infantry, Stonewall Brigade, in their early war uniforms. Notice the white crossbelts across the breast-an inviting target for enemy infantrymen.

Father and Son

They both lived in Lexington. They both professed deep faith in God. They both were friends of Thomas Jonathan Jackson.

William Nelson Pendleton, the Episcopal rector of Grace Church in Lexington, was a West Point graduate who sacrificed his pulpit for the battlefield when the Civil War erupted. He was elected captain of the Rockbridge Artillery, whose four guns were christened "Matthew," "Mark," "Luke," and "John." His battalion of guns on Henry Hill helped to defeat the Federals at First Manassas. Pendleton later served as chief of artillery for R. E. Lee's Army of Northern Virginia.

Alexander "Sandie" Pendleton, a 20-year-old graduate student at the University of Virginia when the war began, joined Jackson's staff in June 1861 as ordnance officer. At First Manassas, his horse was killed, but he escaped unharmed. Jackson appointed young Pendleton his chief of staff in 1862, and he was the only staff member that Stonewall addressed by his first name. "Ask Sandie Pendleton," Jackson once declared when responding to an inquiry about military matters. "If he does not know, no one does."

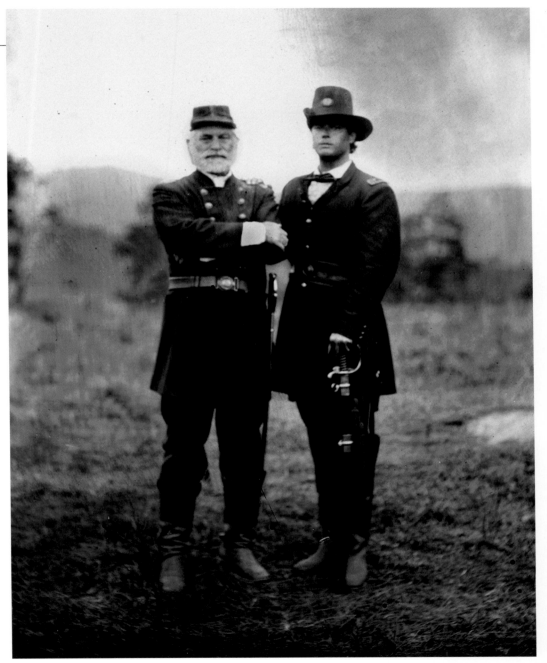

William Nelson Pendleton (John Castle), left, with his son, Sandie Pendleton (Jeremy London).

Farewell, First!

Thomas J. Jackson was promoted to major general on October 7, 1861, and soon ordered to command Confederate forces operating in Virginia's Shenandoah Valley. The Stonewall Brigade initially did not receive instructions to join Jackson in his new assignment. Therefore, before departing on November 4, Jackson addressed his troops near their camp at Centreville, Virginia. It was the only speech Jackson delivered during the war.

Officers and Soldiers of the First Brigade: I am not here to make a speech, but simply to say farewell. I first met you at Harpers Ferry, at the commencement of the war, and I cannot take leave of you without giving expression to my admiration of your conduct from that day to this, whether on the march, the bivouac, the tented field, or on the bloody plains of Manassas, when you gained the well-deserved reputation of having decided the fate of the battle.

Throughout the broad extent of country over which you have marched, by your respect for the rights and property of citizens you have shown that you were soldiers, not only to defend, but able and willing both to defend and protect. You have already gained a brilliant and deservedly high reputation throughout the army and the whole Confederacy, and I trust in the future, by your own deeds on the field, and by the assistance of the same kind Providence who has heretofore favored our cause, you will gain more victories, and add additional luster to the reputation you now enjoy.

You have already gained a proud position in the future history of this, our second war of independence. I shall look with great anxiety to your future movements, and I trust that whenever I shall hear of the First Brigade on the field of battle it will be of still nobler deeds achieved and a higher reputation won.

In the army of the Shenandoah you were the First Brigade; in the army of the Potomac you were the First Brigade. You are the First Brigade in the affections of your general, and I hope by your future deeds and bearing that you will be handed down to posterity as the First Brigade in this our second War of Independence. Farewell!

— Thomas J. "Stonewall" Jackson

We all had the blues, for we did not want to part with him as our commander.
— John O. Casler, Stonewall Brigade

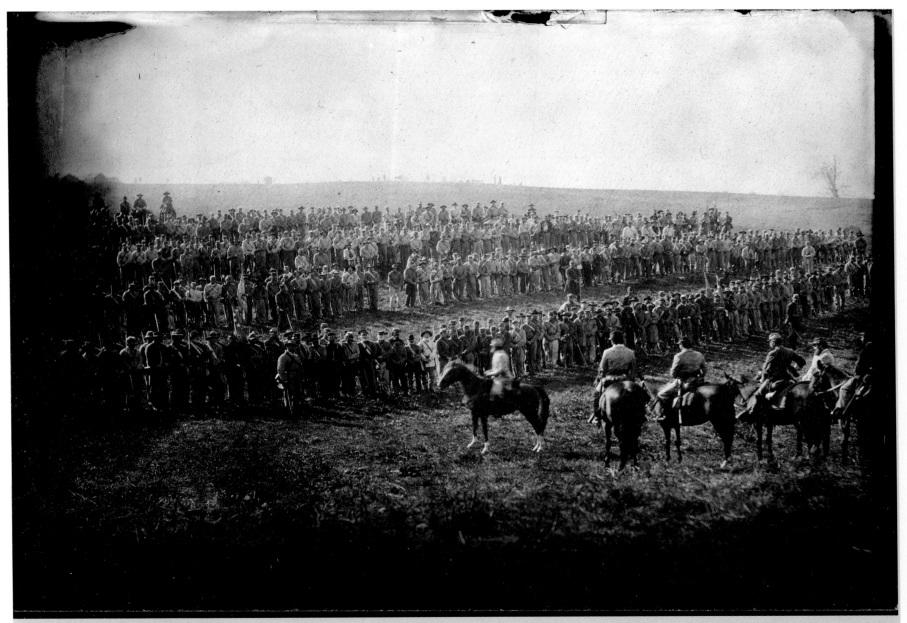

Stonewall Jackson (Stephen Lang), seated on horse facing left in the center of the photograph, bidding farewell to the First Virginia "Stonewall" Brigade. This image was taken on the 1864 Cedar Creek Battlefield near Middletown, Virginia.

Stonewall Revealed

Thomas Jonathan Jackson had experienced hardship and horror with the most important women in his life. His widowed mother, unable to bear the financial burden of the family, orphaned Jackson at age seven. His first wife, to whom he had been married for only fourteen months, died from complications from childbirth. His first daughter passed away only three weeks after delivery. The war drove a spear between Jackson and his sister, who maintained her Union loyalties.

But Mary Anna Morrison brought Jackson the love and peace he so desperately desired. Daughter of a Presbyterian minister, Anna's father also was founder and first president of Davidson College. Born on July 21, 1831, she first met Jackson, who was seven years her elder, at a Lexington social function in 1853. But Thomas was then engaged to Ellie Junkin, daughter of another reverend and president of Lexington's Washington College. Thomas and Ellie soon married, but her untimely death more than one year later made Jackson a 30-year old widower.

Jackson renewed his acquaintance with Anna in 1856, two years after Ellie's death. Although Anna was in North Carolina, Jackson's visits and their frequent exchange of letters developed their love. "I take special pleasure," he wrote Anna, "that the glory of God may be the controlling & absorbing thought of our lives in our new relations. It is to me a great satisfaction to feel that God has manifestly ordered our union."

Married in July 1857, the two honeymooned in New York, with a special venture to Niagara Falls. The couple then returned to Lexington and later purchased a home on Washington Street — the only home Thomas ever owned. Tragedy struck in 1858, when their first child, Mary, died three weeks after her birth from a liver disorder. The despondent couple consoled each other in their grief. Anna remembered Thomas as "the most tender, affectionate and demonstrative man at home that I ever saw." "His heart was soft as a woman's," Anna observed. "[H]e was full of love and gentleness."

A second daughter was born to the Jacksons in November 1862. "My own dear Father" the first person announcement began. "As my mother's letter has been cut short by my arrival, I think it but justice that I should continue it. I know that you are rejoiced to hear of my coming, and I hope that God has sent me to radiate your pathway through life."

Nearly five months passed before Jackson would meet his young daughter, who visited with his mother in the spring of 1863. Their visit was short, as the war soon interrupted the joy of family.

> *I am going to write a letter to the very sweetest little woman I know, the only sweetheart I have; can you guess who she is?*
>
> -- Thomas J. Jackson to his wife

Reunion

I hope to send for you as soon as I can do so.

— Thomas J. Jackson to his wife Anna, November 16, 1861

We traveled by stage-coach from Strasburg, and were told, before reaching Winchester, that General Jackson was not there, having gone with his command on an expedition to demolish Dam No. 5 on the Chesapeake and Ohio Canal. It was therefore with a feeling of sad disappointment and loneliness that I alighted from the stage-coach in front of Taylor's Hotel at midnight...and no husband to meet me with a glad welcome....

My escort led me up the long stairway...and by the time we were upon the top step a pair of strong arms caught me in the rear; the captive's head was thrown back, and she was kissed again and again by her husband....

When I asked my husband why he did not come forward when I got out of the coach, he said he wanted to assure himself that it was his own wife, as he didn't want to commit the blunder of kissing anybody else's esposa.

— Mrs. Jackson's memoirs

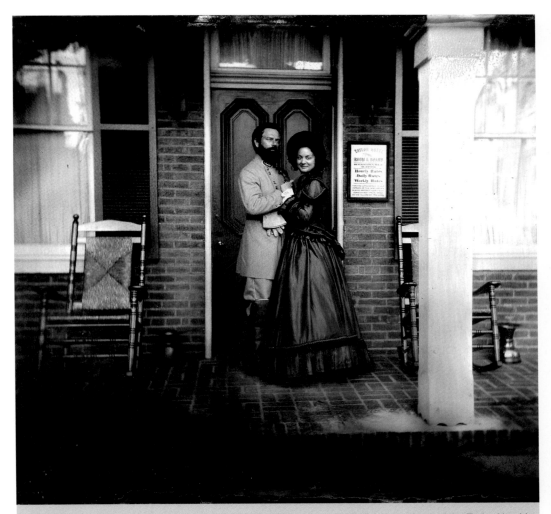

General Jackson (Stephen Lang) reunites with his wife Mary Anna (Kali Rocha) in front of the Taylor Hotel in Winchester, Virginia, in December 1861.

My Esposita

Thomas J. Jackson desperately missed his wife. He longed to be with her. He desired to hold her. He wished to share every day with her.

But the war had separated Thomas from his beloved Anna, and seldom would they meet. Even opportunities for reunion presented impracticalities and hardships. "In reference to coming to see your esposo," Jackson asked Anna in September 1861, "what would you do for privacy in camp? I tell you there are more inconveniences attending camp life for a lady than little pet is aware of."

Since they could not be together, Anna craved news about her husband and matters at the front. "You say that your husband never writes you any news," Jackson noted early in the war. "I suppose you meant military news, for I have written you a great deal about your esposo and how much he loves

you." Then Jackson, practical and logical, asked: "What do you want with military news? Don't you know that it is unmilitary and unlike an officer to write news respecting one's post? You wouldn't wish your husband to do an unofficer-like thing, would you?"

The war did provide one occasion when Thomas and Anna could share some time together. It occurred in Winchester during the winter of 1861-1862, when the couple reveled in each other's presence for nearly three months. Jackson conducted his daily business from his headquarters — and even embarked on a winter campaign — but the time the two spent together proved very special. "The memories of that sojourn in our 'war home' are among the most precious and sacred of my whole life," Anna later recalled. "There was nothing to mar the perfect enjoyment of those three blessed months."

Never again would Anna Jackson have so much time with her husband.

[Y]ou have only to come into the first door on your right if you wish to see your husband, seated on the left of a hickory fire, on the opposite side of the room, writing to his sweetheart, or to his esposita, whichever you may choose to call her.

— Thomas J. Jackson to his wife, October 22, 1861

[A]s my officers and soldiers are not permitted to go and see their wives and families, I ought not to see my esposita, as it might make the troops feel that they were badly treated, and that I consult my own pleasure and comfort regardless of theirs.

— Thomas J. Jackson to his wife, August 17, 1861

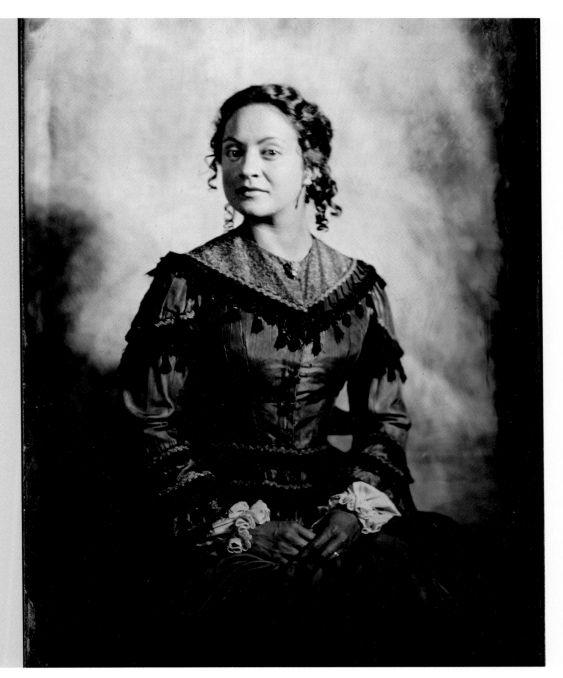

Mary Anna Jackson, portrayed by Kali Rocha

Slavery

The arguments continue today—what caused the Civil War?

Passionate debate still flourishes over this question, but this fact remains—in 1860, more than four million slaves resided in the South.

Slave ownership was a symbol of class and economic wealth. Robert E. Lee and Thomas J. Jackson, as upper-middle class and middle class Southerners, both owned slaves. Since slaves were legally defined as property, Lee inherited most of his slaves through his wife's family, and three of Jackson's six slaves came as a wedding gift from his father-in-law. Although both men were uncomfortable with the "institution"—Lee labeled it in 1856 a "moral and political evil in any Country", and Jackson violated slave laws by hosting a slave Sunday School and teaching his slaves how to read and write— both accepted slavery as a right in Southern culture, and both disdained the meddling of Northern abolitionists.

Slaves served as personal servants for both Lee and Jackson early in the war. At the end of 1862, when Lee emancipated his slaves, he hired Perry as his servant and George as his cook for $8.20 per month. Jackson paid a Lexington man $150 in 1862 to rent Jim Lewis, believed to be a slave from Jackson's home town.

On the subject of slavery, the North and South are not only two Peoples, but they are rival, hostile peoples.

— Charleston Mercury, 1858

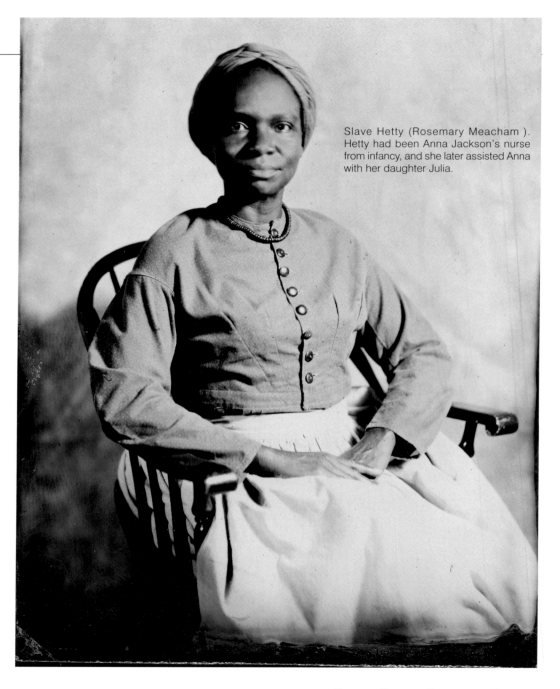

Slave Hetty (Rosemary Meacham). Hetty had been Anna Jackson's nurse from infancy, and she later assisted Anna with her daughter Julia.

The Supreme Fact of God

Stonewall Jackson desired more religion in the ranks. Apprehensive over the sins of the army and the people of the Confederacy, Jackson believed "the lack of morality and spiritual commitment were hindering both the nation and the army." With a "converted army," perhaps victory could be secured.

To inspirit this conversion, Jackson turned to Beverly Tucker Lacy, minister of the Fredericksburg Presbyterian church. During the winter of 1863, Lacy began serving as chaplain of Jackson's Corps, and soon was recruiting, organizing, and directing preachers and spawning religious revival. "Let brevity mark your sermons," he instructed his parsons. "Let the words be few and well chosen Long sermons, weary and injure your usefulness. Be short and sharp; brief, but brimful of the gospel."

Jackson and Lacy became the closest friends. Jackson gave him his best horse, invited Lacy to share his room, and asked the reverend to baptize his daughter Julia. Following Jackson's wounding and the amputation of his left arm, Lacy recovered the limb and buried it in the Wilderness at his brother's home Ellwood, where it remains today. Lacy died in 1900 at age 81, and is buried near his good friend Stonewall in Lexington.

All things were viewed in the light of the supreme fact of God. All things were referred to it. All things were submitted to the rulings of that fact. It covered all other facts, all other truth, it ruled all action, it answered all questions of duty, and made all his life and service one and simple forever.

— James Power Smith Jackson staff officer

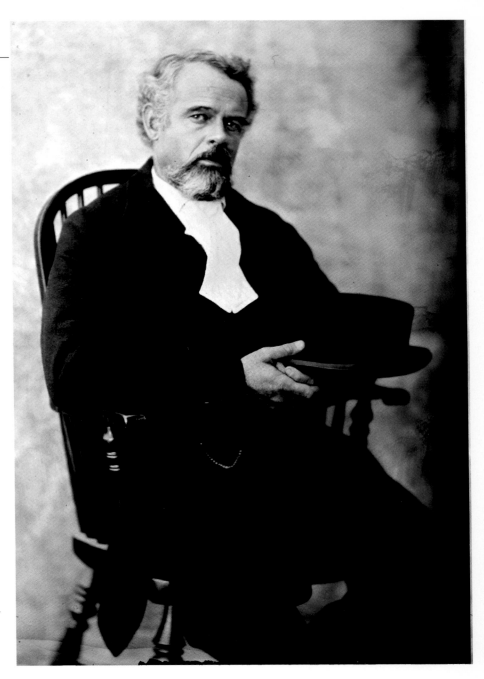

Reverend Beverly Tucker Lacy (David Carpenter)

His Proper Post

He knew he had to go. The Bowdoin College professor of logic and natural theology had studied the war from his classroom for the past sixteen months. But no longer could he remain a distant student. Professor Joshua Lawrence Chamberlain desired to trade his tunic for a Union uniform. He must serve his country.

"I am sensible that I am proposing personal sacrifices," he wrote the Maine governor when applying for a military commission on July 14, 1862, "but I believe this to be my duty, and I know I can be of service to my Country in this time of peril."

Then the 34-year old theologian explained to Governor Washburn his intense willingness to make that sacrifice: "I fear, this war, so costly of blood and treasure, will not cease until the men of the North are willing to leave good positions, and sacrifice the dearest personal interests, to rescue our Country from Desolation, and defend the National Existence against treachery at home and jeopardy abroad."

Chamberlain epitomized departure from a good position. He had just been elected to a new department at Bowdoin, and had been offered the opportunity to spend a year in Europe "in the service of the College." But Chamberlain desired to dismiss the offer, informing the governor: "This war must be ended, with a swift and strong hand; and every man ought to come forward and ask to be placed at his proper post."

Despite entreaties from the Bowdoin faculty to keep Chamberlain in Brunswick, the governor granted his request, assigning him the position of lieutenant colonel in the state's newest regiment, the 20th Maine.

Chamberlain had no military experience, but his genealogy included forebears in the American Revolution and the War of 1812. Despite his ignorance of the science of war, his eager enthusiasm and his ability as a quick study granted him confidence. "[W]hat I do not know in that line I know how to learn," he informed the governor.

He soon discovered he would have to learn fast.

The flag of the Nation had been insulted. The honor and authority of the Union had been defied. The integrity and existence of the People of the United States had been assailed in open and bitter war.

— Joshua L. Chamberlain

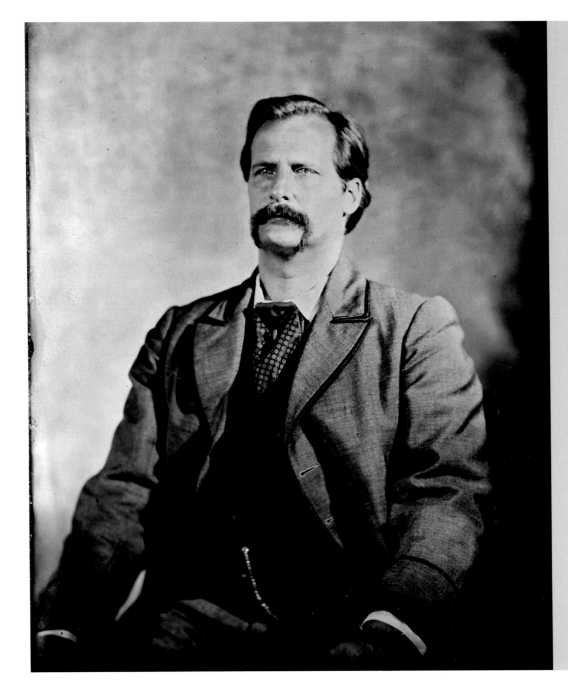

It may sometimes be conducive to a just comprehension of the truth to let others see us as we see ourselves.

— Joshua Lawrence Chamberlain

Joshua Lawrence Chamberlain,
portrayed by Jeff Daniels, pictured
as a professor at Bowdoin College.

Preacher's Daughter, Preacher's Wife

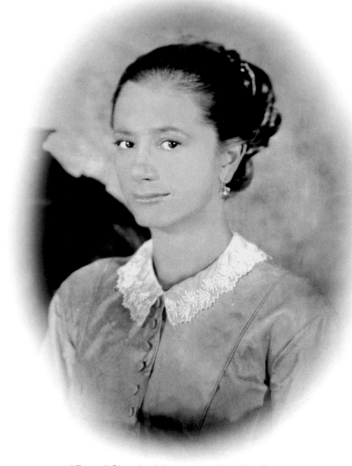

"Fanny" Chamberlain, portrayed by Mira Sorvino.

She adored fancy clothes. She admitted extravagant tastes. She loved beautiful things.

Frances Caroline "Fanny" Adams also loved music. She met her future husband, in fact, playing the organ for Joshua Chamberlain's choir at First Parish Church in Brunswick, Maine.

"Fanny" Adams was the adopted daughter of the Reverend George E. Adams, pastor of First Parish Church. She and Chamberlain met in 1851, while he was in his junior year at Bowdoin College. One year later, they were engaged, but then they parted, not to see each other for three years as Chamberlain attended theological seminary in Bangor and "Fannie" traveled to Georgia where she taught voice at a girls' school, gave private piano lessons, and played the organ at the local Presbyterian church. Despite the separation, the two remained engaged, and on December 7, 1855, they married.

When Chamberlain decided to enter the war nearly seven years later, he fretted over the separation from his wife and two children, six-year old Daisy and three-year old Wyllys. But he did not regret his decision: "I feel that it is a sacrifice for me to be here in one sense of the word; but I do not wish myself back by any means. I feel that I am where duty called me."

Chamberlain did regret that his wife did not write him often. "It is rather discouraging to me to look over a bushel or two of letters & find one for everybody but me," he wrote from near Antietam Ford on October 26, 1862. But despite Chamberlain's calls for more correspondence, "Fanny" wrote him infrequently, claiming her eyes gave her frequent pain, and her many obligations as a mother gave her little time. Still Chamberlain hoped. "I dare say you have written me often," he reasoned, "but there is great irregularity about the mails."

I long to see you – to rush in & have a good frolic with the children, & a sweet sit-down with you in the study....

— Joshua Chamberlain to "Fanny," October 26, 1862

"Fanny" Chamberlain, portrayed by Mira Sorvino, displaying her taste for fancy clothing. Fanny had expensive tastes, paying $20 or $30 for dresses of silk or fine muslin. The average Civil War private's pay started at $12 per month.

Antietam and the First Invasion of the North

Never before had the Confederacy faced such opportunity.

Robert E. Lee had smashed the Union advance against Richmond. His army had driven the Federal invaders out of northern Virginia. Chaos gripped the United States government—its two eastern armies, leaderless and lethargic, hunkered down behind the defenses of Washington—were demoralized, disorganized, and defeated.

General Lee grasped the situation. "The present seems to be the most propitious time since the commencement of the war," he declared to President Jefferson Davis on September 3, 1862, "for the Confederate army to enter Maryland." Yet the Southern commander did not intend to stop at the Mason-Dixon Line. "Should the results of the expedition justify it," he opined to Davis on the following day, "I propose to enter Pennsylvania."

The first invasion of the North thus commenced. By the second week of September, nearly 40,000 Rebels had occupied the western Maryland town of Frederick. Lee was only forty miles from Washington; just forty miles from Baltimore; and less than twenty five miles from Pennsylvania. No one knew his next move. Near panic straggled the North.

Confederate expectations crescendoed. Maryland could be freed from Yankee occupation. Upcoming Congressional elections could turn against Lincoln and the Republicans. Newly elected "peace" Democrats could demand an end to the war. Europe's prestigious powers perhaps could mediate the conflict. An independent Confederacy never appeared so near.

But fortune faded the South's ascending star. Lee divided his army to capture Harpers Ferry, but one copy of his "Special Orders 191" was lost—and then found—by the enemy! "I have all the plans of the rebels," gushed Union commander George B. McClellan in a letter to President Lincoln on September 13, "and will catch them in their own trap. . . . Will send you trophies."

The hunt for trophies began at South Mountain the next day, where McClellan pounded the mountain's gaps, surprising the outnumbered Confederates, forcing a desperate fight for the Southerners' survival. Lee's men survived—but barely. "The day has gone against us," observed a dejected and perplexed Lee on September 14. "This army will go by way of Sharpsburg and cross the [Potomac] river." Lee had canceled his invasion.

Yet the next day, when he received word of Stonewall Jackson's victory at Harpers Ferry—where Jackson bagged 12,700 Union prisoners, the largest surrender of United States troops during the war— Lee changed his mind. In Maryland, he would remain. Along the banks of the Antietam Creek, he would fight.

The Battle of Antietam raged from dawn until dusk on September 17, 1862. It was the bloodiest twelve hours in American military history. Over 23,000 Union and Confederate casualties littered the Maryland soil—four times the losses suffered by American forces during the D-Day invasion. The Cornfield, The West Woods, The Dunker Church, Bloody Lane, and Burnside Bridge were etched into the American epic.

General Lee failed to defeat McClellan at Antietam, but more important, McClellan failed to destroy Lee. The Confederates retreated back to Virginia on the night of September 18, ending the invasion only two weeks after it began.

Opportunities for the South then dimmed. Maryland remained firmly under Union control. Rejoicing Republicans retained their war grip on the Congress. Waffling Europeans decided against intervention. And Abraham Lincoln issued the "Preliminary Emancipation Proclamation," forever changing slavery and the course of a nation.

Never during four years of civil war did the fates of North and South change so dramatically in such short time. Antietam, the bloodiest day, had become the turning point of the war.

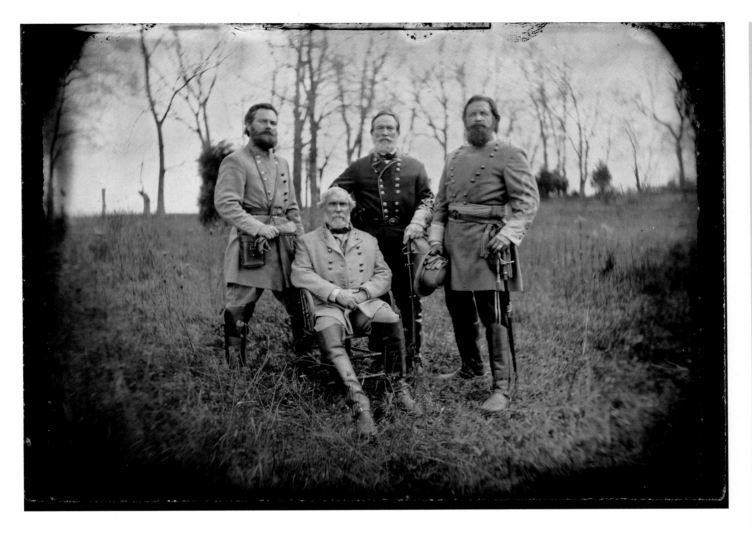

The first invasion of the North began with inauspicious injuries to the Confederacy's commanders. A frightened horse caused General Lee to fall and break a small bone in one hand and severely sprain the other. General Jackson was jolted and bruised when tossed from a young mare presented to him by a Maryland reception committee. General Longstreet replaced one boot with a carpet slipper due to a blistered heel. General Hood, although not injured, was under arrest for insubordination.

Hood regained command of his division at South Mountain; and at Antietam, he engaged in the butchery at The Cornfield. His Texas Brigade suffered 64 percent casualties, compelling Hood to observe his men were "Dead on the field."

Answering the Call

The 20th Maine Goes to War

Abraham Lincoln needed more men. The war continued . . . in Virginia . . . in Tennessee . . . in Mississippi . . . in South Carolina. Hundreds of square miles of the Confederacy had fallen into Union hands, but Federal offensives had skidded to a halt, and Richmond had escaped capture yet again. Southern armies continued to fight with dogged determination, and Rebel bullets continued to kill thousands of young men from the North.

Lincoln thus issued his call in the hot summer of 1862 — 300,000 more soldiers were needed — immediately. Tens of thousands of new volunteers responded within weeks, and dozens of fresh regiments were formed. Maine responded aggressively to the President's plea, and as part of its quota, on August 29, 1862, the 20th regiment mustered in 979 officers and men at Camp Mason near Portland. Colonel Adelbert Ames was assigned command, and Joshua L. Chamberlain was appointed his lieutenant colonel.

Colonel Ames had a regiment, but he certainly did not have soldiers. Hardly a man had any military experience, including Professor Chamberlain. Ames had reason for worry. The West Point graduate had first-hand experience with the war — he had fought at First Manassas, where he was badly wounded in the thigh, and he had witnessed the tragedy of poorly prepared troops. But there was no time for training. Units were needed now to combat the recent reverses in Virginia. Thus, on September 1 — only three days after they joined the army — the "farmers, clerks, lumbermen, storekeepers, lawyers, fishermen, builders, and sailors" of the 20th Maine were on their way to Washington.

The regiments passing to the front marched not between festoons of ladies' smiles and waving handkerchiefs, thrown kisses and banner presentations. They were looked upon sadly and in a certain awe, as those that had taken on themselves a doom. The muster rolls on which the name and oath were written were pledges of honor — redeemable at the gates of death. And they who went up to them, knowing this, are on the lists of heroes.

— Joshua Lawrence Chamberlain

Raw Recruits
Fresh recruits of the 20th Maine Infantry, at Camp Mason, near Portland. The more permanent structures shown here typify Camp Mason as a staging area for new regiments. This scene depicts the movie set near Staunton, Virginia. Photographer Gibson shot this photo on the morning of September 11, 2001 — just prior to learning of the terrorist attacks on the World Trade Center and the Pentagon.

Patriotic Pupils
A company of the 20th Maine, during a break on the march from Washington to Antietam. The new troops covered 54 miles in three days, spurred to meet the emergency of the Confederate invasion of Maryland.

Grim and Grime

We are coming, Father Abraham,
* three hundred thousand more,*
From Mississippi's winding stream
* and from New England's shore;*
We leave our ploughs and workshops,
* our wives and children dear,*
With hearts too full for utterance,
* with but a single tear;*
We dare not look behind us,
* but steadfastly before;*
We are coming, Father Abraham,
* three hundred thousand more!*

The true test of civilization is not the census, nor the
size of the cities, nor the crops; no, but the kind of men
the country turns out.

— Ralph Waldo Emerson

Sergeant Tom Chamberlain (C. Thomas Howell) witnessed his first battle action at Antietam, but only from afar. He would not be so fortunate at his next battle.

50

Lone Warrior

You have called us, and we're coming, by Richmond's bloody tide

To lay us down, for Freedom's sake, our brothers' bones beside;

Or from foul treason's savage grasp to wrench the murderous blade,

And in the face of foreign foes its fragments to parade.

Six hundred thousand loyal men and true have gone before:

We are coming, Father Abraham, three hundred thousand more!

—James Sloan Gibbons

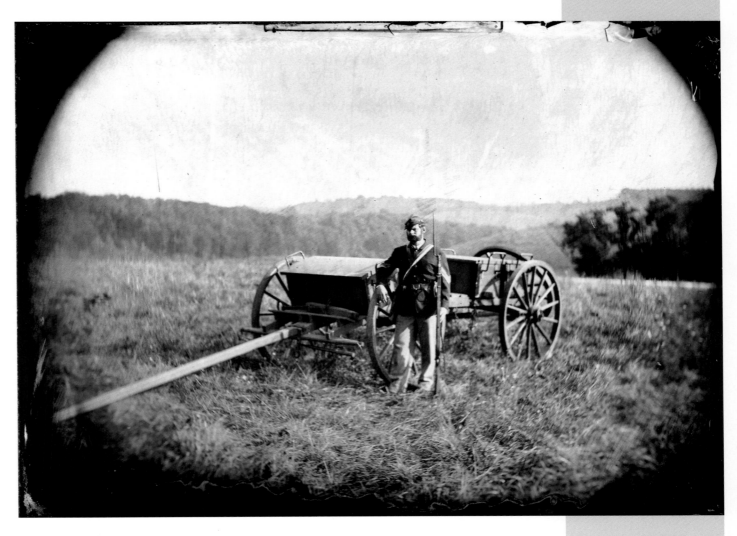

Sergeant Thomas Davee Chamberlain (C. Thomas Howell), younger brother of Joshua, standing with artillery limber and caisson at Antietam. Throughout the battle on September 17, Chamberlain and the 20th Maine remained in reserve, positioned near the long-range Union artillery, more than one mile from the infantry fight.

Macabre Mosaic

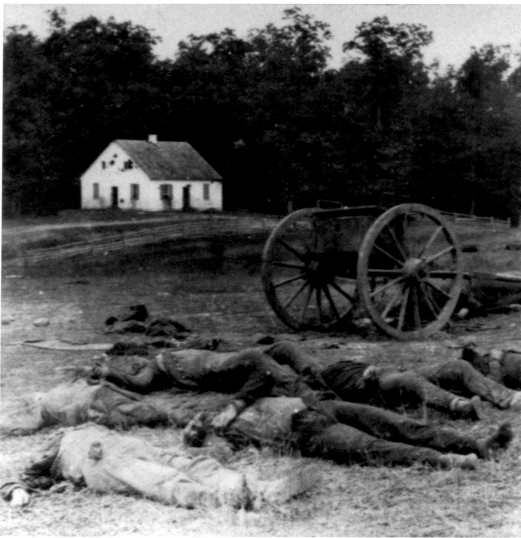

(Photo courtesy USAMHI)

***The First Battlefield
Photographs—
the Dead of Antietam***
*Mr. Brady has done
something to bring home
to us the terrible reality
and earnestness of war. If
he has not brought bodies
and laid them in our door-
yards and along streets,
he has done something
very like it....*

— New York Times,
October 20, 1862

Original image of dead Confederate artillerymen from Parker's Virginia Battery, opposite the shell-torn Dunker Church at Antietam. Photographed September 19, 1862.

Wrecks of War

Antietam was the first battlefield in American history to be photographed shortly after the fighting ended. Photographers Alexander Gardner and James F. Gibson recorded seventy images within five days of the battle, scouring the blood-soaked fields for gruesome and realistic scenes before many of the dead were buried.

During the third week of October, 1862—one month after the battle—some of the photographs appeared in Mathew Brady's gallery in New York City. For the first time, photojournalism brought the horrors of the battlefield to a morbidly captivated public.

Dead Confederate soldiers, killed while attempting to cross the Hagerstown Pike in fighting near The Cornfield. Image by Alexander Gardner, September 19, 1862
(Photo Coutesy of William A. Frassanito, *Antietam: The Photographic Legacy of America's Bloodiest Day.*)

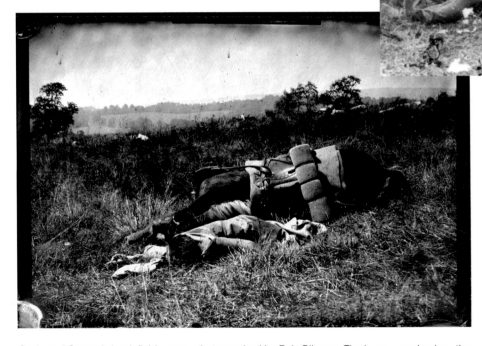

Gods and Generals battlefield scene, photographed by Rob Gibson. The image emphasizes the film company's commitment to reality and authenticity.

[T]here is a terrible fascination about it that draws one near these pictures, and makes him loth to leave them.

There is one side of the picture that the sun did not catch, one phase that has escaped photographic skill. It is the background of widows and orphans, torn from the bosom of their natural protectors by the red remorseless hand of Battle.... Homes have been made desolate, and the light of thousands of hearts has been quenched forever. All of this desolation imagination must paint—broken hearts cannot be photographed.

— **New York Times**, October 20, 1862

Murder Before the Stone Wall

Ambrose Burnside had a good plan. The new commander of the Army of the Potomac believed he could flank the Confederate army, outrace R. E. Lee to Fredericksburg, cross the Rapphannock River unopposed, and then be "On to Richmond" before Lee could catch him.

The first part of the plan worked. Burnside stole a march on Lee, moving the van of his army of 116,000 men to the heights opposite Fredericksburg by November 17, 1862 - fully two days ahead of the bulk of Lee's infantry. Facing virtually no opposition, Burnside then demanded the surrender of the town and threatened to shell it — a threat that panicked many of the town's civilians and soon resulted in a mass evacuation. Burnside's advance abruptly halted, however, when the pontoon bridges required to cross the river failed to arrive with the army. Meanwhile, General Lee responded to the emergency by rushing James Longstreet's Corps toward Fredericksburg. By November 20, Burnside's opportunity to cross the

Rappahannock without interference had vanished.

During the next three weeks, the Confederates built defenses and positioned their cannon on Marye's Heights, west of Fredericksburg, and on the hills further south of town. Jackson's Corps also had arrived by the end of the month, bolstering Lee's numbers to nearly 73,000.

Burnside himself now admitted he faced a "vigilant and formidable foe," and despite considering modifications to his plan, the Union commander determined he still must cross at Fredericksburg. Following a council of war with his leading officers on December 9, Burnside asked Colonel Rush Hawkins what he thought of his plan. "If you make the attack as contemplated," Hawkins responded frankly, "it will be the greatest slaughter of the war." Then Hawkins concluded: "[T]here isn't infantry enough in our whole army to carry those heights if they are well defended."

Burnside remained resolute. On December 11, he ordered the attack to begin. But first the pontoon bridges had to be laid

across the Rapphannock. Here the Yankees encountered trouble, as Mississippi sharpshooters perniciously picked off the bridge engineers. With angry desperation, Burnside ordered nearly 150 cannon to hurl 50 shells per gun at the town. The Union artillery sent down "a perfect storm of shot and shell, crushing the houses with a cyclone of fiery metal." Confederate General Lafayette McLaws remembered the scene: "The roar of the cannon, the bursting shells, the falling of walls and chimneys, and the flying bricks...added to the fire of the infantry from both sides and the smoke from the guns and from the burning houses, made a scene of indescribable confusion, enough to appall the stoutest hearts!"

Following the ferocious bombardment, two pontoon bridges were built opposite the town, joining the three additional bridges constructed one mile downstream. Throughout December 12 and 13, tens of thousands of Union soldiers crossed the Rappahannock. Much of the city was ransacked by marauding soldiers on the 12th.

The attacks were launched the next day. On the Confederate right, Jackson's line experienced a temporary breach, but the Union assaults failed. On the left-center, where Longstreet's legions defended the stone wall at the base of Marye's Heights, wave after wave of Union brigades were chopped down by tornadoes of bullets and shells. In the Irish Brigade alone, 545 men of the 1,300 who attacked became casualties. Winfield Scott Hancock's division lost 2,049 soldiers — 42 percent of its strength — the greatest divisional loss in the Union army in any battle in the war.

One Confederate infantryman who witnessed the repeated Federal charges summarized Fredericksburg best when he exclaimed: "Ye Gods! It is no longer a battle, it is a butchery!"

Pernicious Pontoons

The failed arrival of the pontoon bridges spoiled Burnside's plan to seize Fredericksburg before the appearance of the Confederate army. Bungled communications had stalled the pontoons' shipment, and they did not reach Burnside until six days after he first arrived at the Rappahannock. By then, it was too late — Lee and Longstreet were in position on the opposite bank.

Even construction of the two bridges leading into town proved challenging — and dangerous. The Union engineers were harassed by sharpshooters from William Barksdale's Mississippi Brigade as they attempted to span the 400 foot-wide river. Finally on the afternoon of December 11, following a ferocious bombardment of the town, Union infantry crossed the river in boats and cleared the opposite shore of the "Confederate hornets."

If the pontoons had been there, we might have crossed at once.
— Maj. Gen. Darius Couch, USA

Dear Mother —

[I]f our present plans are carried out, the great battle of the war will commence.... I have little hope of the plans succeeding. I do not think them good - there will be a great loss of life and nothing accomplished.
— Col. Rush C. Hawkins, USA

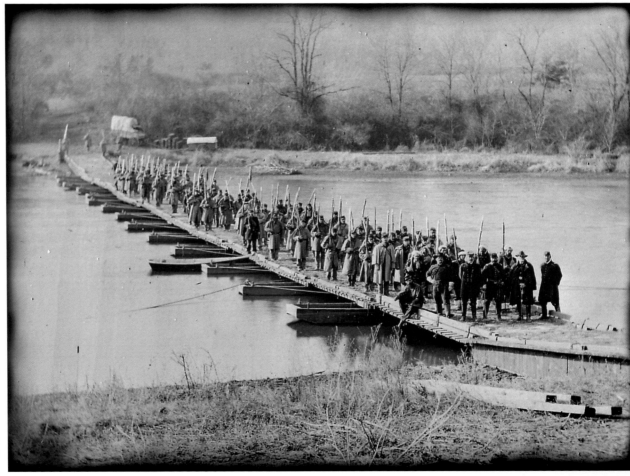

Union infantry crossing a pontoon bridge into Fredericksburg. The movie set for this scene is on a lake in Blair's Valley near Clear Spring, Maryland.

It is well that war is so terrible, or we should grow too fond of it.

— R. E. Lee, commenting on the Battle of Fredericksburg

Fredericksburg was the easiest battle we ever fought.

— Lt. Colonel E. Porter Alexander, CSA

Lee and members of his command at Fredericksburg. General Lee (Robert Duvall) is located at center. General Longstreet (Bruce Boxleitner) is in the broad-rimmed hat to immediate right of Lee. General Jackson (Stephen Lang) stands to the left of Lee. Second from right is U. S. Senator Robert C. Byrd, portraying Brig. Gen. Paul Semmes.

A Gift for Stonewall

The dashing, flashy, and flamboyant Jeb Stuart had had enough. Stonewall Jackson needed a new uniform, and Stuart would provide it. In December 1862, just prior to the Battle of Fredericksburg, the new uniform coat, tailor-made in Richmond, arrived. Stuart asked Heros von Borcke to deliver it to General Jackson.

Major General James Ewell Brown "Jeb" Stuart (Joseph Fuqua). Chief of Cavalry, Army of Northern Virginia.

I found him in his weather-stained coat, from which all the buttons had been clipped long since by patriotic ladies, and which, from exposure to sun and rain and powder-smoke, and by reason of many rents and patches, was in a very unseemly condition.... I produced General Stuart's present, in all its magnificence of gilt buttons and sheeny facings and gold lace, and I heartily amused at the modest confusion with which the hero of many battles regarded the fine uniform from many points of view, scarcely daring to touch it....
— Heros von Borcke

Major Heros von Borcke (Matt Lindquist). A 6'4", 240-pound Prussian who joined Stuart's staff in 1862, von Borcke reportedly carried the longest saber in the army.

The rumor of the change ran like electricity through the neighboring camps, and the soldiers came running by hundreds to the spot, desirous of seeing their beloved Stonewall in his new attire.
— Heros von Borcke, CSA

The Gray Wall

About eighty yards in front [of us] the plowed field was bounded by a stone wall, and behind the wall were men in gray uniforms moving carelessly about. This picture is one of my most distinct memories of the war—the men in gray behind this wall, talking, laughing, cooking, cleaning muskets, clicking locks— there they were! Lee's soldiers!—the Army of Northern Virginia.

— Captain John Worthington Ames, 11th U.S. Infantry

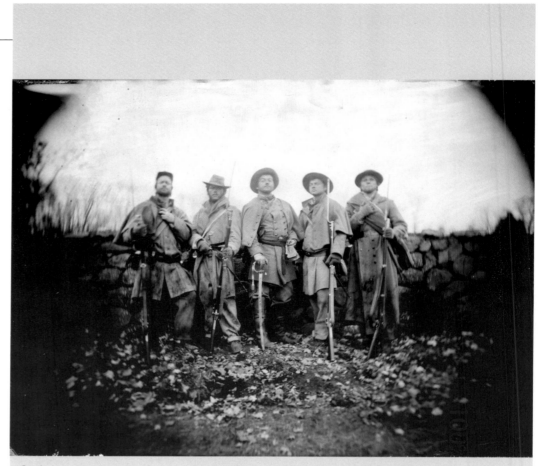

Confederate soldiers preparing for battle at the stone wall at the base of Marye's Heights at Fredericksburg. This image shows the movie set on a farm near Keedysville, Maryland, where all the attacks against Marye's Heights were filmed. Most of the original battlefield today is covered by streets and housing.

Hell of Fire

As twilight neared on December 13, the 20th Maine engaged in its first assault of the war. It charged to within 150 yards of the stone wall as darkness ended the final attacks of the day. The 20th then hunkered down upon the cold, wet earth — so close to the enemy that the men could hear their voices — for the next day and a half.

At last, on that second midnight [December 14], having been in that hell of fire for thirty-six hours, an order came that we were to be relieved.... [We witnessed] an Aurora Borealis, marvelous in beauty. Fiery lances and banner of blood, and flame, columns of pearly light, garland and wreaths of gold — all pointing and beckoning upward. Befitting scene! Who would die a noble death, or dream of more glorious burial. Dead for their country's honor, and lighted to burial by their meteor splendors of the Northern home!

— Lt. Col. Joshua Chamberlain

On we charged, over fences and through hedges, over bodies of dead men and the living ones, past four lines that were lying on the ground...on to that deadly edge, where we had seen so much desperate valor mown down in heaps.... Then, on the crest of the hill we exchanged swift and deadly volleys with the rebel infantry before us.

— Lt. Col. Joshua Chamberlain

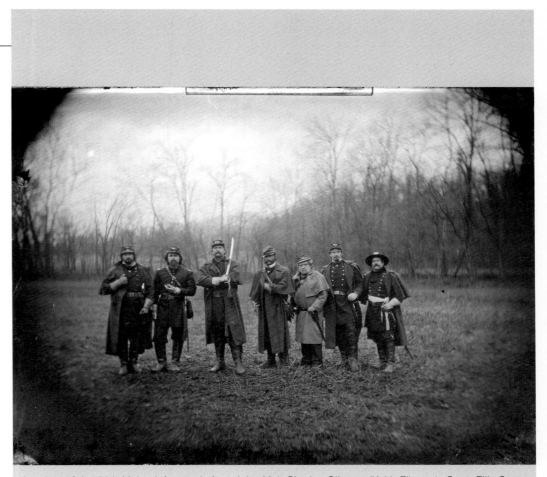

Leaders of the 20th Maine Infantry. Left to right, Maj. Charles Gilmore (Keith Flippen); Capt. Ellis Spear (Jonathan Maxwell); Lt. Col. Joshua Chamberlain (Jeff Daniels); Lt. Tom Chamberlain (C. Thomas Howell); Sgt. Buster Kilrain (Kevin Conway); Col. Adelbert Ames (Matt Letscher); and Brig. Gen. Charles Griffin (Matt Miller).

Concert of Cannon

[M]ore than half of Burnside's whole army was preparing to assault us...come right out from the town, & strike where we were strongest. If we couldn't whip it we couldn't whip anything, & had better give up the war at once & go back to our homes. From that moment I felt the elation of a certain & easy victory, & my only care then was to get into it somehow & help do the enemy all the harm I could.

— E. Porter Alexander

A chicken could not live on that field when we open on it.

— E. Porter Alexander

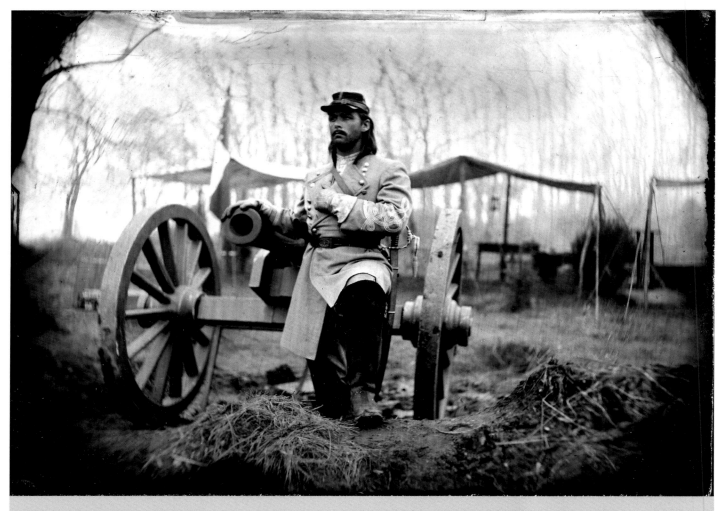

Lieutenant Colonel Edward Porter Alexander (James Patrick Stuart) overlooking the Fredericksburg battlefield. He served as the Army of Northern Virginia's chief ordnance officer and also commanded a battalion of 26 cannon at Fredericksburg. Alexander positioned the guns on Marye's Heights that rained hundreds of deadly shells upon the hapless Union attackers.

Fatal Fate

Oh, great God! see how our men, our poor fellows, are falling!
— Maj. Gen. Darius Couch, USA

There was no cheering on the part of the men, but a stubborn determination to obey orders and do their duty. I don't think there was much feeling of success. As they charged[,] the artillery fire would break their formation and they would get mixed; then they would close up, go forward, [and] receive the withering infantry fire...and then the next brigade...would do its duty and melt like snow coming down on warm ground.

— Maj. Gen. Darius Couch, commander, Second Corps

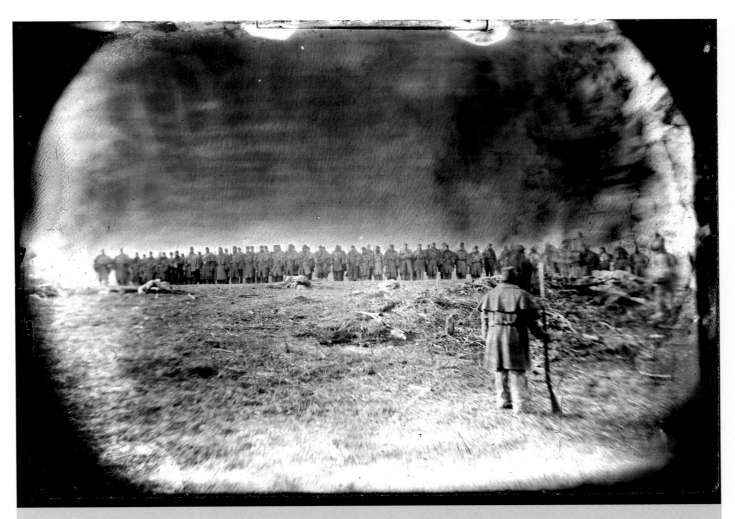

A regiment of Federal infantry, in battle formation, preparing to attack the stone wall at Marye's Heights. Notice the dead from previous assaults. This scene was shot on the Fredericksburg battlefield set on a farm near Keedysville, Maryland.

Victims of War

When I went into town a horrible sight presented itself —
All the buildings more or less battered with shells, roofs
& walls all full of holes & churches with their broken
windows & shattered walls looking desolate enough —
But this was not the worst — The Soldiery were sacking
the town! Every house and Store was being gutted! Men
with all sorts of utensils & furniture — all sorts of
eatables & drinkables & wearables, were carried off. I
found one fellow loading up a horse with an enormous
load of carpeting & bedding[.] I ordered him to unload
it, which failing to do, I gave him a cut or two with my
riding whip that started him in a hurry & then put him
with my prisoners
— Brig. Gen. Marsena Patrick, Union Army Provost Marshal

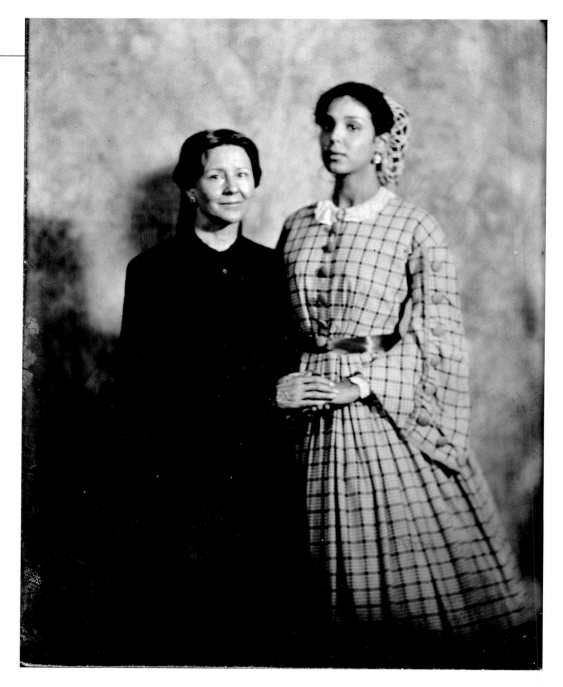

Jane Beale (Mia Dillon), left, and daughter Lucy Beale (Karen Goberman).
The Beale family huddled in their basement during the bombardment, but
then fled as the Union army advanced into town.

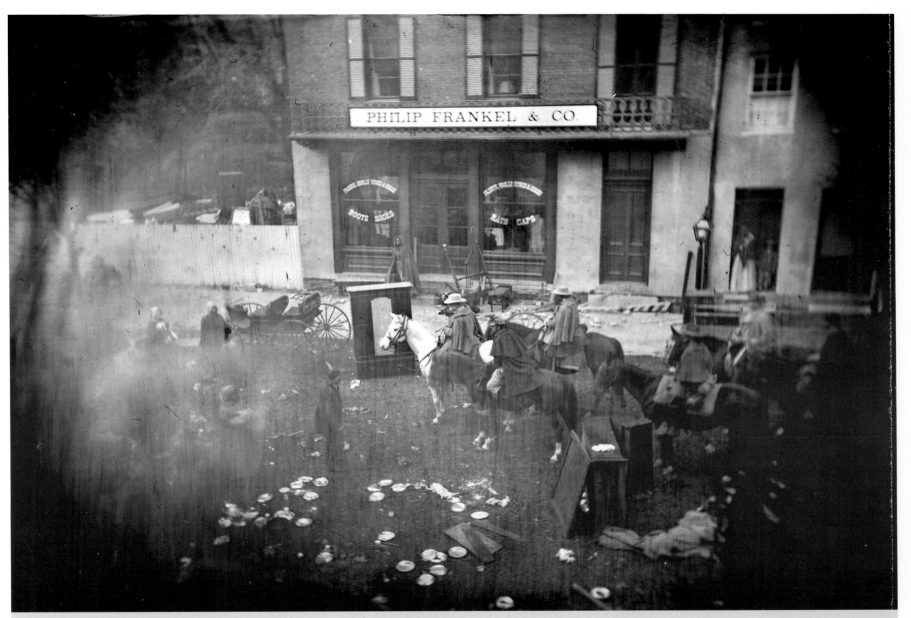

Destruction in Fredericksburg. This image shows the movie set on Shenandoah Street in Harpers Ferry National Historical Park. Note the broken furniture, the strewn clothes, and the scattered plates. In center frame, on the white horse, is R. E. Lee (Robert Duvall) inspecting the damage following the Confederate victory.

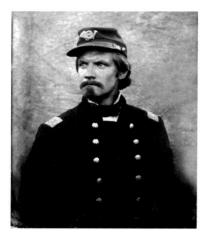

Colonel Adelbert Ames
20th Maine Infantry
(Matt Letscher)

Sergeant Buster Kilrain
20th Maine Infantry
(Kevin Conway)

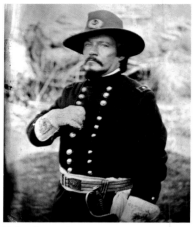

Major General
Winfield Scott Hancock
Division commander
(Brian Mallon)

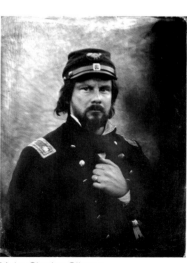

Major Charles Gilmore
20th Maine Infantry
(Keith Flippen)

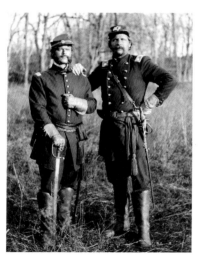

The Chamberlain Brothers
Left: Tom (C. Thomas Howell)
Right: Joshua (Jeff Daniels)

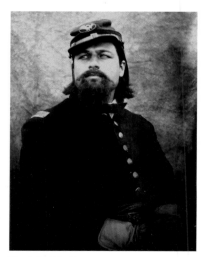

Captain Ellis Spear
20th Maine Infantry
(Jonathan Maxwell, son of the director)

Faces at Fredericksburg – The Defenders

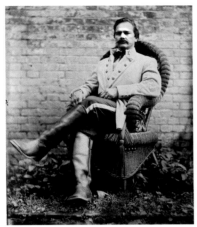

Major Walter H. Taylor
Lee's adjutant general
(Bo Brinkman)

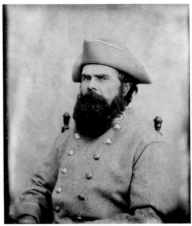

Lieutenant General James Longstreet
Corps commander
(Bruce Boxleitner)

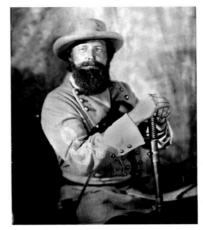

Brigadier General Maxcy Gregg
Mortally wounded
(Buck Taylor)

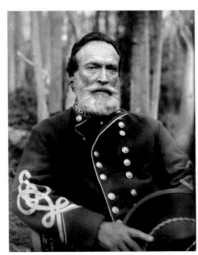

Major General John Bell Hood
Division commander
(Patrick Gorman)

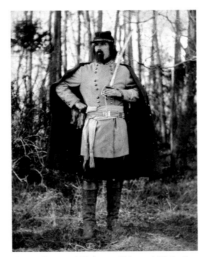

Major General George Edward Pickett
Division commander
(Billy Campbell)

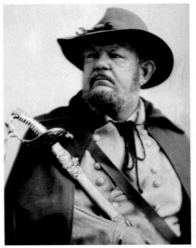

Brigadier General James Lawson Kemper
(Royce Applegate)
(tragically killed in a Hollywood house fire, December 2002)

Winter Peace

The fighting paused, but the war continued. During the winter of 1862-1863, the two armies spread out on opposite sides of the Rappahannock, the river itself forming the boundary between Blue and Gray. Both armies constructed crude quarters of logs and mud, and the demand for firewood deforested hundreds of acres. The landscape became barren: rain and snow produced quagmires, and the haze of wood smoke clouded the horizon.

It was a time for letter-writing, for snowball fights, for religious revivals, and for rest. Stonewall Jackson hosted a Christmas party at his headquarters at Moss Neck, where Generals Lee, Stuart, and William Nelson Pendleton enjoyed a feast of turkey, ham, and oysters. Jackson spent the winter comfortably ensconced in a small office building adjoining the Moss Neck mansion, and there he reviewed battle reports, identified his conditions and wants, and maintained close communication with General Lee.

On the Federal side of the river, confusion, anger, and frustration initially reigned. The disaster at Fredericksburg and General Burnside's ill-fated "Mud March" in January demoralized the army. Uniforms had turned into rags. Pay was promised but not delivered. Furloughs were not granted, and desertion became epidemic. This malaise reversed, however, when President Lincoln appointed the energetic and bombastic Joseph Hooker as new commander of the army. Hooker's remedies returned spirit to his men — and an eager anticipation for the spring campaign.

And the nature of the war changed. On January 1, 1863, President Lincoln's Emancipation Proclamation became official. It did not free slaves everywhere, but the abolition of slavery became a war measure. No one knew the future; but for the first time, many slaves now had a future.

Glorious dawn of the year which is destined to form an epic in the future history of our young nation. All hail to thee sixty-three
— Lucy Rebecca Buck, diary entry, January 1, 1863

A dreamy sort of existence [spent] in the most humdrum way imaginable.
— Jedediah Hotchkiss, Jackson's chief engineer

The "Jackson Club"

This stool is one of the relics cherished by our mess. It belonged to our dear friend, Gen'l. Jackson & we, Smith, McGuire, & I, cling fondly to everything that reminds us of him, and glory in our title of the "Jackson Club," as we are called by the rest of our military family. . . . Oh! How often have I sat by Gen'l. Jackson as we gathered around the camp fire, and joined in cheerful conversation. A regular happy family we were in those days.

— Sandie Pendleton, Jackson's chief of staff

General Jackson and his staff in winter quarters at Moss Neck. Jackson is seated on a stool similar to the one Sandie Pendleton remembers. From left to right in the back row, Pendleton (Jeremy London); Dr. Hunter McGuire (Sean Pratt); Joseph Morrison (Scott Cooper); and James Power Smith (Stephen Spacek). This movie set photo was taken on a farm near Keedysville, Maryland.

Respite

R. E. Lee and his generals enjoying live entertainment, and singing *The Bonnie Blue Flag*, during the winter lull of 1863. South Carolina, the first state to secede from the Union, adopted a blue flag bearing a single white star in its center.

Lee (Robert Duvall) is seated in the front row just right of center. To the left is James Longstreet (Bruce Boxleitner), and to the right sits Stonewall Jackson (Stephen Lang). Jackson moved slightly when the picture was taken, accounting for the blur. Ted Turner is also visible in this photograph. Can you locate him?

We are a band of brothers,
and native to the soil.
Fighting for the property
we gained by honest
toil
And when our rights were
threatened, the cry
rose near and far,
Hurrah for the Bonnie
Blue Flag that bears a
single star!

Interlude

The 2nd South Carolina String Band that entertained Lee and his generals. Notice the period instruments, including a small hand accordion on the right. A palmetto tree is painted on the banjo in the center of the photograph.

Cameo Stars

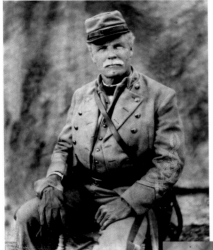

Ted Turner
Benefactor of the movie *Gods and Generals,* reprising his Gettysburg role as Colonel Waller Tazwell Patton (great-uncle of World War II general George S. Patton).

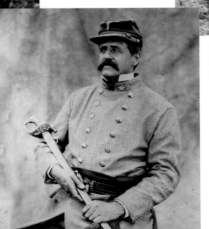

Jeff Shaara
Author of the best-selling historical novel *Gods and Generals*, upon which the movie is based.

George Allen, United States Senator – Virginia, accompanied by his son.

Robert C. Byrd
United States Senator – West Virginia, filmed on set on his 83rd birthday.

Conviction

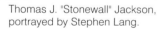

Thomas J. "Stonewall" Jackson,
portrayed by Stephen Lang.

Jackson was a man of the deepest conviction — one who demanded everything from his own self, and had no compunction about demanding everything from those who served under him. Jackson was a man that constructed a set of principles, by which he led his life. He applied these principles rigorously, and he adhered to them religiously. We often describe someone in terms of adjectives. Jackson is a dogged man, a secretive man, an unpredictable man, an awkward man, an elegant man, an unrelenting, passionate, unselfconscious, studious, and devout person.

— Stephen Lang

Unforgiven

An execution in Jackson's Corps. The three blind folded men on the right were found guilty of desertion and sentenced to death by firing squad (seen far left). Stonewall Jackson had no tolerance for deserters — "Men who desert their comrades in war deserve to be shot!"

Games and Grief

Stonewall Jackson loved children. The war, unfortunately, had separated him from his wife and his newborn child (whom he had not yet met). So, during the winter of 1863, while Jackson was headquartered at Moss Neck, five-year old Jane Corbin became the delight of Stonewall's daily life. "He made himself the playmate of Janie Corbin," recalled James Power Smith, "with whom he played and romped for an hour or more each afternoon." The two engaged in conversation, strolled on walks, and exchanged gifts. Jackson once presented the young lass with the gilt braid from his hat, pinning it around her hair, and saying: "Jane, it suits a little girl like you better than it does an old soldier like me." A string of hand-cut paper dolls made by Jane was a prized decoration at Old Jack's headquarters.

This surrogate father-daughter relationship ended abruptly—and tragically. As spring neared and Jackson moved his headquarters to Yerby's at Hamilton Crossing, Jane contracted scarlet fever. Despite the best efforts of Dr. McGuire, Jackson's physician, the disease killed the girl. Jackson openly wept when he learned the news.

Little Jane Wellford Corbin—unconscious of her country's & parents' struggles, happy in her innocence and ignorance.

> — Henry Kyd Douglas, officer on Jackson's staff
> Diary entry, December 26, 1862

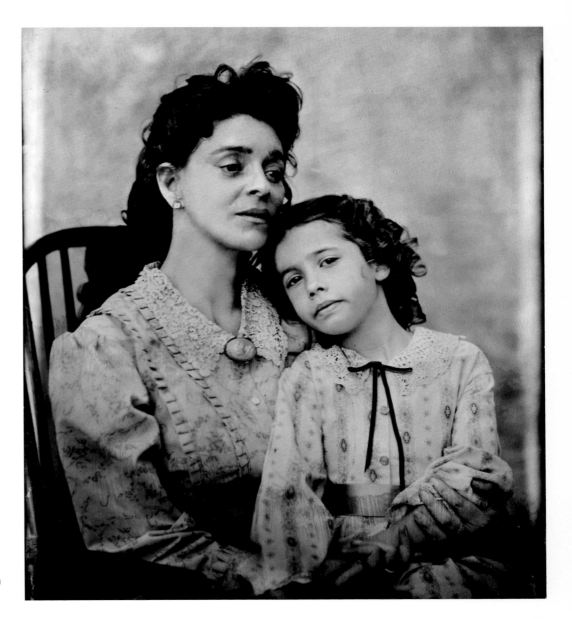

Roberta "Bertie" Corbin (Karen Hochsetter) with daughter Jane Corbin (Lydia Jordan).

Winter Love

While encamped at Moss Neck during the winter of 1863, Sandie Pendleton fell in love with 24-year old Katherine "Kate" Corbin. "A man does not begin to live truly, & as he ought, until he deeply loves," discovered Sandie. Upon learning of the betrothal of Kate and Sandie, General Jackson remarked, "[I]f he makes as good a husband as he has a soldier, Miss Corbin will do well."

Finding time for marriage during a war proved difficult for the couple, but finally, on December 29, 1863, the couple exchanged vows, with Sandie's father officiating, attended by groomsmen and former Jackson staff members James Power Smith and Hunter McGuire.

Nine months later, Sandie was dead—victim of a mortal wound inflicted in the abdomen at the Battle of Fisher's Hill. Six weeks later, widow Kate delivered their baby son.

The war had taken . . . but also given.

One thing I know, I am a better soldier & a better man for having associated so long & intimately with Gen'l. Jackson; and I know also, in which knowledge you are interested, that I shall make you a better husband

— Sandie Pendleton to his fiancee Kate Corbin

Katherine "Kate" Corbin
(Christie Lynn Smith)

Sandie Pendleton
(Jeremy London)
Jackson's chief of staff

*Oh, girls, get married. . . .
[T]he evils are not as
bad as you might
suppose.*

— Kate Corbin to her sister
and a friend

Brothers

Christmas Day Diary

I cannot but feel a little sad this morning for my thoughts continually revert to those dear absent brothers who were wont to share our Christmas cheer and gladden the hours of this festive season for us. Poor boys! I wonder if they think of the blazing hearthstone...and wish for a place in the home-circle. When I think of the unexpected changes that have occurred in the last year I feel as if I could not count upon ever having them with us again....

I think of how many hands that wreathed the bowl and twined the holly last year are now mouldering in the dust. The bright locks that were then crowned with roses, now dabbled in gore and covered with the turf of the battlefield. I think of the bright eyes that softened neath the love glances of fond friends then, how they look forth now with a yearning, hopeless gaze from the close grating of the gloomy prison window. I think of it all and sicken when I think.

— Lucy Rebecca Buck, age 19, Front Royal, Virginia

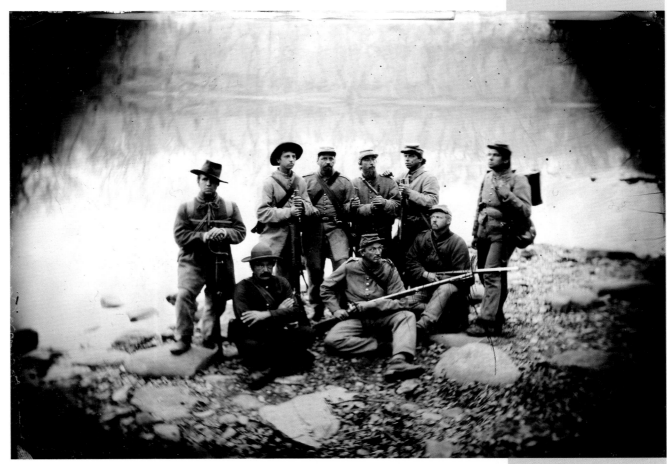

Confederate pickets, winter, 1863. This scene represents the Rappahannock River, the border between the two armies. The image actually was made in Maryland at the Potomac River and the mouth of the Antietam Creek (far right of photo). Ironically, this image was recorded on December 13, 2001—exactly 139 years after the Battle of Fredericksburg. It also was the last day of principal filming for the movie.

Jackson's Final Battle

Chancellorsville

The Fatal Shot

Spring had arrived. The armies were rested. The roads were drying and the rivers dropping. All knew that battle would soon commence, but no one knew where...or when.

Except Joseph Hooker. The newest commander of the Army of the Potomac had devised his strategy. Hooker would divide his army of 130,000 — the largest army that ever opposed the Confederates — into two parts. Over half this force would swing around R. E. Lee's left flank and approach Fredericksburg from the west. A second prong would strike directly at Fredericksburg, either pinning Lee between the two pinching claws, or forcing him to retreat southward toward Richmond, where Federal cavalry would gobble up the defeated and demoralized Rebels.

It almost worked. By April 30, 1863, Hooker's flanking column, with lightening speed, had crossed both the Rappahannock and Rapidan rivers. The Federals had driven to Chancellorsville, a crossroads tavern in Virginia's Wilderness, about ten miles west of Fredericksburg, encountering

virtually no opposition. Lee had been caught off guard. "The operations of the last three days," Hooker gloated, "have determined that our enemy must either fly or come out from behind his defenses and give us battle on our own ground."

But then Hooker made a serious error. Mysteriously, he halted. Instead of continuing his drive against Lee's rear, he stopped — at Chancellorsville. General Lee now had his opportunity.

Though outnumbered more than two to one, Lee determined to sacrifice his Fredericksburg position, and to turn the bulk of his army west toward Hooker. By May 1, Confederate divisions aggressively attacked the Federals near Chancellorsville. Suddenly, and unexpectedly, a bewildered Hooker witnessed his offensive churn into a defense.

But the Confederates found a hole in Hooker's defense. His right flank was unprotected. Lee and Jackson then devised a scheme to gain advantage from this oversight, and on May 2, Jackson commenced one of the most famous flanking marches of

the Civil War. Hooker's men discovered the column, but it was so long and so vast, Hooker misinterpreted the signal and believed the Confederates were retreating. He abruptly learned otherwise, when Jackson unleashed over 21,000 yelling, charging gray coats against the exposed Union right. Like a thunderbolt, Jackson's fury resulted in a tumultuous rout, but not a complete victory. Hooker's army buckled, but it did not break.

Frustrated that he had not cut off Hooker's line of retreat, Jackson began scouting for roads in the darkness. His determination placed him precariously between contesting lines, and the result was a near catastrophe — Jackson was shot, accidentally, by his own men.

The wounded general was removed to the rear, where his wounds were treated, and his left arm amputated. On May 3, the Confederates renewed the assault, without Jackson, capturing the ground around Chancellorsville; but still the Federal army refused to break. On the fourth, the battle continued once again — this time with Lee defending against an

assault by a Union force advancing from Fredericksburg. Finally, Joe Hooker had had enough. He began retreating back across the Rappahannock on May 5. The Chancellorsville Campaign had ended.

Robert E. Lee had won his greatest victory, but he had lost his great lieutenant. In a few days, the army would learn that Stonewall Jackson would fight no more battles.

He has lost his left arm, but I have lost my right.

— R. E. Lee

He was like an avalanche coming from an unexpected quarter, like a thunderbolt from a clear sky.

— James Power Smith,
Jackson staff officer

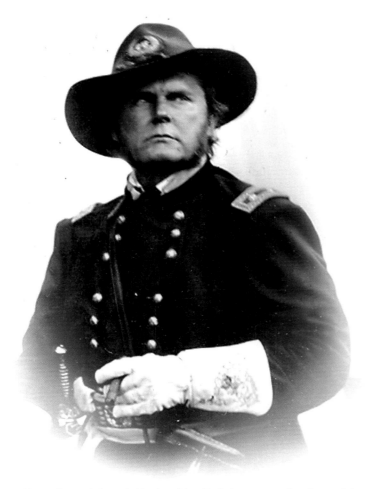

Major General Joseph Hooker (Mac Butler), commander, Army of the Potomac, at Chancellorsville.

My plans are perfect, and when I start to carry them out, may God have mercy on General Lee, for I will have none.

— Maj. Gen. Joseph Hooker, USA

Now beware of rashness. Beware of rashness, but with energy and sleepless vigilance, go forward and give us victories.

— President Abraham Lincoln

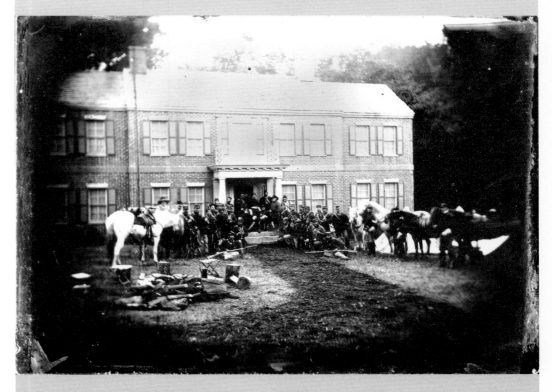

Major General Joseph Hooker (Mac Butler) and his headquarters guard at Chancellorsville. Hooker is leaning against the column at the right front of the portico. On May 3, 1863, during the actual battle, Hooker will be standing here when a Confederate shell will plow through the right front of the portico and knock him unconscious. This Chancellorsville set is a front facade only, with the rear supported by three-stories of railroad containers. This set was located on a farm near Keedysville, Maryland.

The Last Meeting

They met in the damp darkness. They spoke practically in whispers. A candle flickered over a map, reflecting the studious faces of Confederate commanders Lee and Jackson. They were discussing an attack on the morrow, May 2. The Union army was digging in within the tangled Wilderness. Where was its weakness? What roads were available? What strategy should be employed?

Suddenly, galloping up in the darkness, arrived Jeb Stuart. The cavalry commander had important news — Hooker's right flank was vulnerable! It was dangling along the Orange Turnpike. The Army of the Potomac was exposed.

Lee quickly employed this welcome news to devise his plan. With his finger tracing faint roads upon the map, he instructed Jackson to make a sweeping march to the west to assail the enemy's right flank. As Jackson smashed the right, Lee would deliver a second blow from the south. The plan was set, and the two men parted. Soon both attempted to sleep, but the need for more details and anxious anticipation kept both minds active and alert.

By 3:30 a.m., the two generals once again were in earnest conversation, sitting upon cracker boxes in the forest. Jackson's chief engineer, Jedediah Hotchkiss, had joined the meeting, and was suggesting a route for the flank march. "What do you propose to make this movement with?" Lee asked Jackson. "With my whole corps," Old Jack responded. "What will you leave me?" Lee then inquired, somewhat startled by Jackson's audacity. "The divisions of Anderson and McLaws," answered Jackson.

Lee paused. If he followed Jackson's recommendation, only two Confederate divisions blocked the Union army's route to Richmond. The risk was great; the consequences could be fatal. But Lee agreed — Stonewall would have his corps. Lee, once again, had placed his faith in Jackson. Jackson now placed his faith with God.

Neither realized that God had his own plan...and that they had just shared their last meeting.

> *Some time after midnight I was awakened by the chill of the early morning hours, and turning over, caught a glimpse of a little flame on the slope above me, and sitting up to see what it meant I saw, bending over a scant fire of twigs, two men seated on old cracker boxes and warming their hands over the little fire. I had to rub my eyes and collect my wits to recognize the figures of Robert E. Lee and Stonewall Jackson.... Who can tell the story of that quiet council of war between two sleeping armies? Nothing remains on record to tell of plans discussed, and dangers weighed, and a great purpose formed, except the story of the great day so soon to follow.*
>
> — James Power Smith, Jackson staff officer

Confident Confidants

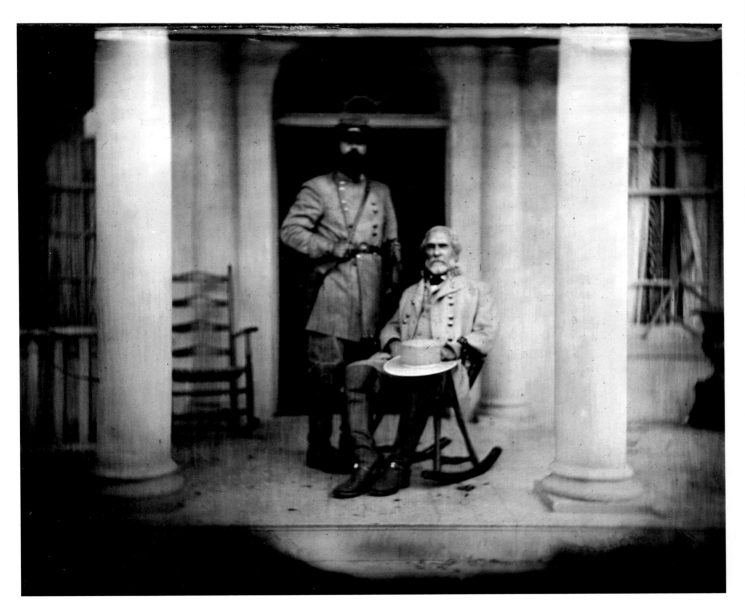

R. E. Lee (Robert Duvall), seated, and Stonewall Jackson (Stephen Lang). The porch in this image is a movie set depicting a building in downtown Fredericksburg. No known photographs exist showing Lee and Jackson together during the war.

Stonewall

Stonewall Jackson's men were used to marching. His famous "foot cavalry" had tramped hundreds of miles in the past two years. Marches to meet the enemy. Marches to deceive the enemy. Marches to outflank the enemy. Marches to invade the enemy's country. Marches in the mud, the rain, the heat, the dust, the snow, the ice. As one of his soldiers refrained: "Man that is born of woman and enlists in Jackson's Army, has but few days to live, short rations and much hard tack, sleeps but little and marches many miles."

Yet something was different about this march that began about 7:30 a.m. on May 2, 1863. The men knew the future of their army — and their country — depended upon their march.

Their objective — the exposed right flank of the Federal army near Chancellorsville. Through the tangled wilderness the column advanced — seventy infantry regiments; four regiments of cavalry; twenty one batteries and eighty guns — all totaled 26,000 Confederates. The narrow column stretched, in a semicircle, nearly ten miles, with the front making two and a half miles per hour, and the rear one and a half.

Finally, as 5 p.m. neared, the line of battle had been formed to attack the Union right. The rear of the column had not yet arrived, but Jackson could wait no longer. Only two and a half hours of daylight remained.

Jackson ordered the attack to begin at 5:15 p.m. Stonewall was launching his final assault.

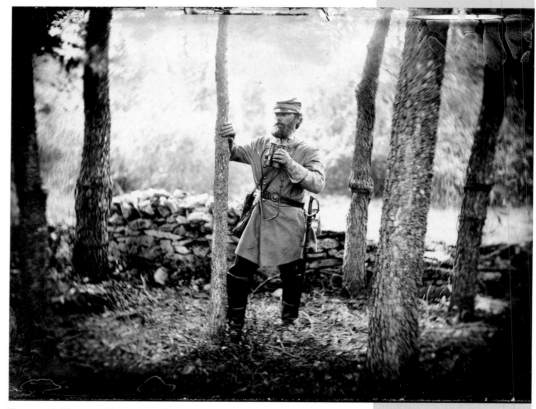

Thomas J. "Stonewall" Jackson (Stephen Lang).

Outwardly, Jackson was not a stone wall, for it was not in his nature to be stationary and defensive but vigorously active.... And yet he was in character and will more like a stone wall than any man I have known.

— James Power Smith, Jackson staff officer

Before the Storm

The Federals in Oliver O. Howard's Eleventh Corps suspected something. As many were preparing dinner on the early evening of May 2nd, a strange sight leaped from the forest to their west. "Like a cloud of dust driven before a rain shower," recollected General Howard, "startled rabbits, squirrels, quail, and other game [appeared] flying wildly hither and thither in evident terror."

Then followed the most horrifying sight — thousands of Confederate infantry — stretched hundreds of yards on both sides of the Orange Turnpike — bearing down on the unprepared Federals. "The surprise was complete," mused Major David Gregg McIntosh of Jackson's artillery. "The shock was too great; the sense of utter helplessness was too apparent." McIntosh observed any resistance was "speedily beaten down." "There was nothing left but to lay down their arms and surrender, or flee," he continued. "They threw them away, and fled. Arms, knapsacks, clothing, equipage, everything, was thrown aside and left behind."

The surging Confederates drove the startled Yankees for more than two miles, but resistance stiffened near Hooker's Chancellorsville headquarters. Jackson's lines also were in disarray due to the extended charge through the woods. As darkness neared, momentum disappeared.

Stonewall's surprise had worked. But his victory was not yet complete.

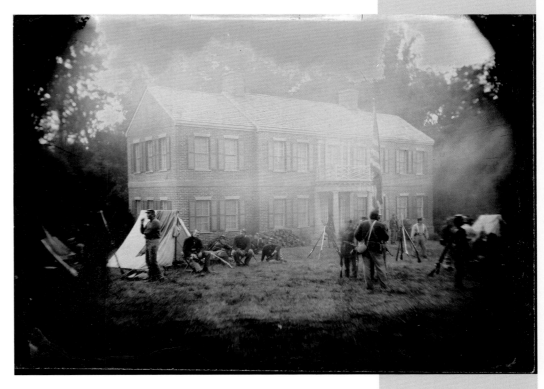

They did run and make no mistake about it — but I will never blame them. I would have done the same thing and so would you and I reckon the Devil himself would have run with Jackson in his rear.

— O. A. Wiggins, CSA

With all the fury of the wildest hailstorm, everything, every sort of organization that lay in the path of the mad current of panic-stricken men, had to give way and be broken into fragments.

— Maj. Gen. O. O. Howard, USA

Federal soldiers lounging around Chancellorsville just prior to the Confederate attack. Chancellorsville was not a town, but a crossroads, defined by this prominent structure.

The Fatal Shots

Stonewall Jackson was dissatisfied. He had routed the Federals, but he had not cut off their line of retreat back across the Rappahannock River. Despite the disorganization and exhaustion of his troops, and despite the evening darkness, Jackson determined he must press forward. The victory must be complete.

While searching for a road leading to the enemy's rear, Jackson and his reconnoitering party passed beyond Confederate lines. They now were in a hazardous position—between friend and foe—as Jackson quietly and diligently probed the blackened wilderness. Suddenly, shortly before 10 p.m. on May 2, gun shots pierced the silence. The forest then screamed with volleys. Jackson was struck!—with Confederate bullets!—from rifles of the 18th North Carolina. Friendly fire dropped their general, but the Tarheels did not know.

The general received three balls at the same instant. One penetrated the palm of his right hand and was cut out that night from the back of his hand. A second passed around the wrist of the left arm and out through the left hand. But a third ball passed through the left arm halfway from shoulder to elbow. The large bone of the upper arm was splintered to the elbow-joint, and the wound bled freely.

— James Power Smith

Witness to Tragedy: An Account by James Power Smith

Cutting open the coat sleeve from wrist to shoulder, I found the wound in the upper arm, and with my handkerchief I bound the arm above the wound to stem the flow of blood.... Being outside of our lines, it was urgent that he should be moved at once. With difficulty litter-bearers were brought from the line near by, the general placed upon the litter, and carefully raised to the shoulder, I myself bearing one corner. A moment after, artillery from the Federal side was opened upon us; great broadsides thundered over the woods; hissing shells searched the dark thickets through, and shrapnel swept the road along which we moved. Two or three steps farther, and the litter bearer at my side was struck and fell, but, as the litter turned, [we] happily caught it. But the fright of the men was so great we were obliged to lay the litter and its burden down upon the road. As the litter bearers ran to the cover of the trees, I threw myself by the general's side, and held him firmly to the ground as he attempted to rise....

The litter was soon brought, and again rallying a few men, we essayed to carry him farther, when a second bearer fell at my side. This time, with no one to assist, the litter careened, and the general fell to the ground, with a groan of deep pain....

Raising him again to his feet, he was accosted by Brigadier General Pender: "Oh, general, I hope you are not seriously wounded. I will have to retire my troops to re-form them, they are so much broken by this fire." But Jackson, rallying his strength, with firm voice said: "You must hold your ground, General Pender; you must hold your ground, sir!" and so uttered his last command on the field.

Mending the Fractured Stonewall

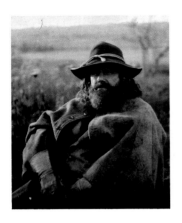

**Major General
Ambrose Powell Hill
(William Sanderson)**

The first general to arrive at Stonewall's side following his wounding. Before departing to take command of Jackson's Corps, Hill stated: "I will try to keep your accident from the knowledge of the troops."

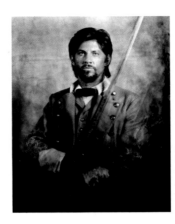

**Captain James Power Smith
(Stephen Spacek)**

In September 1862 Jackson invited 25-year old James Power Smith, the son of a minister and a theological student before the war, to join his staff. After accompanying Jackson to a hospital on the night of his fatal wounding, Smith held the light during the amputation of Jackson's left arm. "All night long it was mine to watch by the sufferer and keep him warmly wrapped and undisturbed in his sleep."
Following Jackson's death, Smith accompanied Mrs. Jackson to her parents' home in North Carolina. In 1869, Smith became minister of the Presbyterian Church in Fredericksburg, where he remained pastor for 23 years. Smith died in 1926 at age 86—the last survivor of Stonewall Jackson's staff.

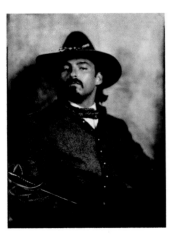

**Lieutenant
Joseph Graham Morrison
(Scott Cooper)
Jackson's aide and brother-in-law.**

Morrison's horse was killed during the initial salvo aimed at Jackson's party. He then raced toward the 18th North Carolina, yelling "Cease firing! You are firing into your own men!" The plea proved futile in the dark and confusing melee in the forest.

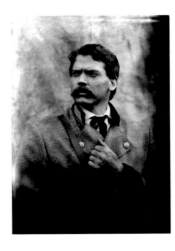

**Dr. Hunter Holmes McGuire
(Sean Pratt)**

As medical director of Jackson's Corps, McGuire tended to Jackson's wounds, amputated his left arm, and later treated his pneumonia upon his deathbed. "His calmness amid the dangers which surrounded him, and at the supposed presence of death," recalled McGuire, "were remarkable.... He controlled, by his iron will, all evidence of emotion."

Epilogue

Jackson's Death

Mary Anna Jackson thought her husband was dead. A casket captured her eyes as she arrived at the Guiney Station depot. Her sudden scare was relieved, however, when she learned the corpse was not her beloved Thomas.

When Mrs. Jackson arrived at the Chandler estate on May 7, she found her husband in a private office building nearby the mansion. Jackson's health had worsened. He had survived the twenty-seven mile journey from the battlefield, and had recovered well from the wounds and the amputation. But pneumonia was killing the general. "My darling," Jackson tendered when awakening to his grieving wife, "you must cheer up and not wear a long face. I love cheerfulness and brightness in a sickroom."

Three more suspenseful days passed. Jackson's condition deteriorated. By Sunday, May 10, Dr. McGuire knew the end was near. He informed Anna, who then spoke to her husband: "Do you know the doctors say you must very soon be in Heaven?"

Afternoon arrived. A distraught Sandie Pendleton visited the general. "The whole army is praying for you," Pendleton whispered. Jackson responded: "Thank God. They are very kind." Then, after a pause, Jackson continued: "It is the Lord's day. My wish is fulfilled. I have always desired to die on Sunday."

The Funeral

Sandie Pendleton and James Power Smith dressed Jackson's body, and on May 11, the funeral cortege left Guiney Station on a special train for Richmond. A procession occurred among an immense throng in the Confederate capital the next day, and on May 13, the funeral party began its trip to Lexington via the James River and Kanawha Canal. The packet boat reached Lexington on the afternoon of the 14th, and a corps of cadets received the remains, escorted it to VMI, and placed it in the lecture room formerly used by Jackson. The casket was wrapped in a newly designed Confederate states flag given by President Davis to Mrs. Jackson. On May 15, the funeral occurred at Jackson's own place of worship, the Lexington Presbyterian Church, and he then was buried in the town cemetery.

**Headquarters Army of Northern Virginia,
May 11, 1863
General Order No. 61.**

With deep grief the commanding General announces to the army the death of Lieutenant General T. J. Jackson, who expired on the 10th instant, at quarter past 3 p.m. The daring, skill and energy of this great and good soldier, by the decree of an Allwise Providence, are now lost to us.

But while we mourn his death we feel that his spirit still lives, and will inspire the whole army with his indomitable courage and unshaken confidence in God as our hope and strength.

Let his name be a watchword to his corps, who have followed him to victory on so many fields.

Let his officers and soldiers emulate his invincible determination to do everything in the defense of our beloved country.

R. E. Lee, General

Surely General Jackson must recover. God will not take him from us, now that we need him so much.... When a suitable occasion offers, give him my love, and tell him that I wrestled in prayer for him last night as I never prayed, I believe for myself.

— R. E. Lee to Reverend Lacy, May 10, 1863

When the Lord in His infinite wisdom, decided it was best for the South to lose, He realized it was necessary to dispose of His servant Stonewall first.

— James Power Smith

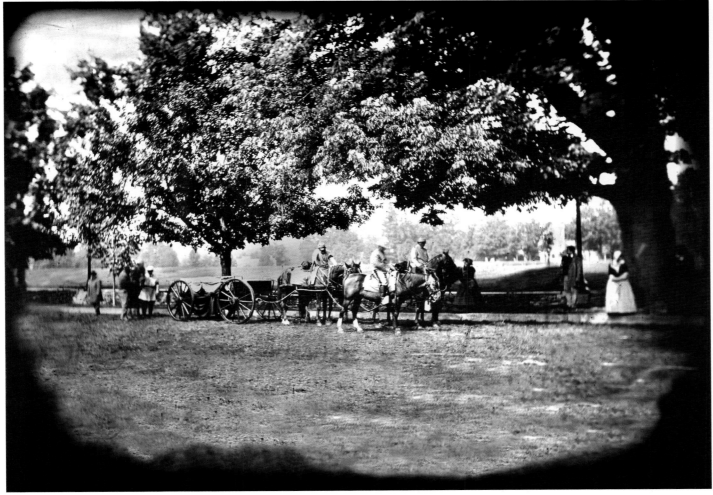

Jackson's funeral procession arrives at Lexington and the Virginia Military Institute. At far left is Jim Lewis (Frankie Fazen), Jackson's personal servant, in a position of honor, leading the riderless horse.

He was the idol of the whole army.
— John O. Casler, Stonewall Brigade

Let us cross over the river and rest under the shade of the trees.
— Stonewall Jackson's final words, May 10, 1863

Notes

For complete bibliographic citations, see Suggested Reading List

Chapter 1: The War Begins
page 18. Freeman, *R. E. Lee*, I, pp. 445, 436-437.
page 19. Freeman, *R. E. Lee*, I, pp. 442-443.
page 20. Freeman, *R. E. Lee*, I, p. 421; Robertson, *Stonewall Jackson*, p. 211.
page 21. Freeman, *R. E. Lee*, I. pp. 466, 468.
page 22. McMurry, *Virginia Military Institute Alumni in the Civil War*, pp. 61, 63, 65. Robertson, *Stonewall Jackson*, pp. 117, 122.
page 24. Smith, *With Stonewall Jackson*, pp. 69, 71; Robertson, *Stonewall Jackson*, pp. 33, 73.
page 25. Smith, p. 92; Schildt, *Jackson and the Preachers*, p. 92.
page 26. Douglas, *I Rode with Stonewall*, p. 6.
page 27. Miller, *Poetry and Eloquence*, p. 52.
page 28. *Official Records*, Series I, Vol. 2, pp. 814-815. Imboden, *Battles and Leaders*, I, pp. 121-122.

Chapter 2: First Blood – Manassas
page 30. Robertson, *Stonewall Jackson*, p. 264. John Casler, *Four Years in the Stonewall Brigade*, p. 37.
page 31. Casler, pp. 45-46.
page 32. Casler, p. 40.
page 33. Bean, *Stonewall's Man: Sandie Pendleton*, p. 89.
page 34. Casler, pp. 57-58.

Chapter 3: War and Romance
page 36. Mary Anna Jackson, *Memoirs of Stonewall Jackson*, p. 195. Robertson, *Stonewall Jackson*, pp. 183, 645.
page 37. Mary Anna Jackson, pp. 210-211.
page 38. Mary Anna Jackson, pp. 159, 186,196, 215.
page 39. Mary Anna Jackson, p. 183.
page 40. McPherson, *Battle Cry of Freedom*, p. 41. Thomas, *Robert E. Lee*, p. 172.
page 41. Smith, p. 70. Schildt, pp. 148, 154.
page 42. Nesbitt, *Through Blood & Fire*, pp. 8-10.
page 43. Chamberlain, *The Passing of the Armies*, p. xi.
page 44. Nesbitt, pp. 25-27.
page 45. Nesbitt, p. 28; Trulock, *In the Hands of Providence*, p. 50.

Chapter 4: The Bloodiest Day — Antietam
page 46. *Official Records*, series I, vol. 19, part 2, pp. 590, 592, 281.
page 48. Nesbitt, p. 9; Trulock, p. 13.
page 50. Smith, p. 62; Miller, pp. 344-345.
page 51. Miller, pp. 344-345.
page 52. Frassanito, *Antietam: America's Bloodiest Day*, p. 16.
page 53. Frassanito, *Antietam*, pp. 16, 288.

Chapter 5: Massacre at Fredericksburg
page 54. *Battles & Leaders*, vol. 3, pp. 126, 75, 87.
page 55. *Battles & Leaders*, vol. 3, pp. 107, 126.
page 56. Alexander, *Fighting for the Confederacy*, p. 185. Thomas, p. 271.
page 57. von Borcke, pp. 295-296.
page 58. *Battles and Leaders*, vol. 3, pp. 122-125.
page 59. Nesbitt, pp. 40-41, 43.
page 60. Alexander, p. 175; *Battles and Leaders*, vol. 3, p. 79.
page 61. *Battles and Leaders*, vol. 3, p. 113.
page 62. Patrick, *Inside Lincoln's Army*, pp. 188-189.

Chapter 6: Winter Peace
page 66. Buck, *Sad Earth, Sweet Heaven*, p. 160; Bean, p. 105.
page 67. Bean, p. 178.
page 68. Miller, p. 344.
page 70. Robertson, *Stonewall Jackson*, p. 542.
page 71. Bean, p. 103. Smith, pp. 80, 29.
page 72. Bean, pp. 179, 182-183, 186, 111.
page 73. Buck, pp. 11-12.

Chapter 7: The Fatal Shot — Chancellorsville
page 74. Smith, p. 61.
page 75. Hebert, *Fighting Joe Hooker*, p. 196.
page 76. Smith, p. 46; Robertson, *Stonewall Jackson*, pp. 713-714.
page 77. Smith, p. 46.
page 78. Smith, p. 61; Robertson, *Stonewall Jackson*, pp. 717, 721.
page 79. *Battles and Leaders*, vol. 3, pp. 197-198; Robertson, *Stonewall Jackson*, p. 722.
page 80. Smith, pp. 51-53.
page 81. Smith, p. 53; Robertson, *Stonewall Jackson*, pp. 728, 732. Schildt, *Hunter Holmes McGuire*, pp. 66-67.

Epilogue
page 82. Casler, p. 155; Schildt, *Jackson and the Preachers*, p. 159; Robertson, *Stonewall Jackson*, pp. 750-752.
page 83. Smith, p. 54. Casler, p. 155.

Suggested Reading

Battle of First Manassas

Davis, William C. *Battle at Bull Run: A History of the First Major Campaign of the Civil War.* Reprint. Baton Rouge, LA: Louisiana State University Press, 1981.

Battle of Antietam

Frassanito, William A. *Antietam: The Photographic Legacy of America's Bloodiest Day.* Reprint. Gettysburg, PA: Thomas Publications, 1975.

Harsh, Joseph. *Taken at the Flood: Robert E. Lee and Confederate Strategy in the Maryland Campaign of 1862.* Kent, OH; Kent State University Press, 1999.

McGrath, Thomas. *Maryland September: True Stories from the Antietam Campaign.* Gettysburg, PA: Thomas Publications, 1977.

McPherson, James M. *Crossroads of Freedom: Antietam (Pivotal Moments in American History).* New York, NY: Oxford University Press, 2002.

Murfin, James V. *The Gleam of Bayonets: The Battle of Antietam and Robert E. Lee's Maryland Campaign.* Baton Rouge, LA: Louisiana State University Press, 1982.

Sears, Stephen W. *Landscape Turned Red: The Battle of Antietam.* Reprint. New York, NY: Mariner Books, 1993.

Battle of Fredericksburg

Rable, George C. *Fredericksburg! Fredericksburg!* Chapel Hill, NC: University of North Carolina Press, 2002.

O'Reilly, Francis A. *The Fredericksburg Campaign: Winter War on the Rappahannock.* Baton Rouge, LA: Louisiana State University Press, 2003.

Battle of Chancellorsville

Furgurson, Ernest B. *Chancellorsville 1863: The Souls of the Brave.* New York, NY: Vintage Books, 1993.

Sears, Stephen. *Chancellorsville.* New York, NY: Houghton Mifflin Co., 1998.

Civil War Photograpy

Frassanito, William A. *Antietam: The Photographic Legacy of America's Bloodiest Day.* Reprint. Gettysburg, PA: Thomas Publications, 1975.

___.*Early Photography at Gettysburg.* Gettysburg, PA: Thomas Publications, 1983.

___. *Gettysburg: A Journey in Time.* Reprint. Gettysburg, PA: Thomas Publications, 1975.

___. *Grant & Lee: The Virginia Campaigns 1864-1865.* Reprint. Gettysburg, PA: Thomas Publications, 1983.

Katz, D. Mark. *Witness to an Era: Life & Photography of Alexander Gardner.* Nashville, TN: Rutledge Hill Press, 1991.

Kelbaugh, Ross J. *Introduction to Civil War Photography.* Gettysburg, PA: Thomas Publications, 1991.

Osterman, Mark. *Wet Plate Collodion Manual.* Rochester, NY: George Eastman House — International Museum of Photography, 1997.

Panzer, Mary. *Mathew Brady and the Image of History.* Washington, DC: Smithsonian Institution Press, 1997.

Zeller, Bob. *The Civil War in Depth: History in 3-D/With Viewer. Vol, I.* San Francisco, CA: Chronicle Books, 1997.

___. *The Civil War in Depth: History in 3-D/With Viewer. Vol. II.* San Francisco, CA: Chronicle Books, 2000.

Biographies
Joshua L. Chamberlain

Chamberlain, Joshua L. *Bayonet! Forward! My Civil War Reminiscences.* Gettysburg, PA: Stan Clark Military Books, 1994.

——. *The Passing of the Armies.* Reprint. Gettysburg, PA: Stan Clark Military Books, 1994.

Levinsky, Alan. *At Home with the General: A Visit to the Joshua L. Chamberlain Museum.* Gettysburg, PA: Thomas Publications, 2002.

Loski, Diana. *The Chamberlains of Brewer.* Gettysburg, PA: Thomas Pubications, 1998.

Nesbitt, Mark. *Through Blood and Fire: Selected Civil War Papers of Major General Joshua Chamberlain.* Mechanicsburg, PA: Stackpole Books, 1999.

Smith, Diane Monroe. *Fanny & Joshua: The Enigmatic Lives of Fanny and Joshua Chamberlain.* Gettysburg, PA: Thomas Publications, 1999.

Trulock, Alice Rains. *In the Hands of Providence: Joshua L. Chamberlain and the American Civil War.* Chapel Hill, NC: University of North Carolina Press, 1992.

Wallace, Willard M. *Soul of the Lion: A Biography of General Joshua L. Chamberlain.* Reprint. Gettysburg, PA: Stan Clark Military Books, 1995.

Thomas J. "Stonewall" Jackson

Davis, Burke. *They Called Him Stonewall: A Life of Lt. General T.J. Jackson, C.S.A.* Reprint. New York, NY: The Fairfax Press, 1988.

Henderson, G.F.R. *Stonewall Jackson and the American Civil War.* Reprint. New York, NY: Da Capo Press, 1988.

Jackson, Mary Anna. *Memoirs of Stonewall Jackson.* Reprint. Dayton, OH: Morningside Bookshop, 1985.

Robertson, James I., Jr. *Stonewall Jackson: The Man, the Soldier, the Legend.* New York, NY: McMillan Publishing Co., 1997.

Vandiver, Frank. *Mighty Stonewall (Texas A&M University Military History Series, Vol. 9).* Reprint. College Station, TX: Texas A & M University Press, 1992.

Robert E. Lee

Connelly, Thomas L. *The Marble Man: Robert E. Lee and His Image in American Society.* Baton Rouge, LA: Louisiana State University Press, 1978.

Dowdey, Clifford. *Lee: A Biography of Robert E. Lee.* Reprint. Gettysburg, PA: Stan Clark Military Books, 1991.

Freeman, Douglas Southall. *R. E. Lee: A Biography.* New York: Charles Scribner's Sons, 1934.

Thomas, Emory. *Robert E. Lee: A Biography.* New York, NY: W.W. Norton & Company, 1997.

Other Sources

Alexander, E. Porter. *The Personal Recollections of Edward Porter Alexander.* Ed.: Gary W. Gallagher. Chapel Hill, NC: University of North Carolina Press, 1989.

Battles and Leaders of the Civil War. 4 volumes. New York, NY: The Century Co., 1884.

Bean, W. G. *Sandie Pendleton: Stonewall's Man.* Wilmington, NC: Broadfoot Publishing Co., 1987.

Billings, John D. *Hardtack & Coffee or the Unwritten Story of Army Life.* Reprint. Lincoln, NE: University of Nebraska Press, 1993.

Buck, Lucy R. *Sad Earth, Sweet Heaven: The Diary of Lucy Rebecca Buck.* Birmingham, AL: The Cornerstone, 1973.

Casler, John O. *Four Years in the Stonewall Brigade.* Reprint. Dayton, OH: Morningside Bookshop, 1982.

Coates, Earl J. and Dean S. Thomas. *An Introduction to Civil War Small Arms.* Gettysburg, PA: Thomas Publications, 1990.

Coco, Gregory A. *The Civil War Infantryman: In camp, on the march, and in battle.* Gettysburg, PA: Thomas Publications, 1996.

Douglas, Henry Kyd. *I Rode with Stonewall.* Reprint. Chapel Hill, NC: University of North Carolina Press, 1940.

Goolrick, William K. *Rebels Resurgent: Fredericksburg to Chancellorsville.* Alexandria, VA: Time-Life Books, 1985.

Hebert, Walter H. *Fighting Joe Hooker.* New York: The Bobbs-Merrill Co., 1944.

Leisch, Juanita. *Introduction to Civil War Civilians.* Gettysburg, PA: Thomas Publications, 1994.

___. *Who Wore What: Women's Wear, 1861-1865.* Gettysburg, PA: Thomas Publications, 1995.

McMurry, Richard. *Virginia Military Institute Alumni in the Civil War.* Lynchburg, VA: H.E. Howard, Inc., 1999.

McPherson, James. *Battle Cry of Freedom: The Civil War Era.* New York, NY: Oxford University Press, 1988.

Miller, Francis Trevelyan. *The Photographic History of the Civil War: Poetry and Eloquence from the Blue and Gray.* Reprint. New York: Thomas Yoseloff, 1957.

Official Records of the War of the Rebellion. 128 volumes. Washington, D.C.: Government Printing Office.

Patrick, Marsena. *Inside Lincoln's Army: The Diary of General Marsena Rudolph Patrick, Provost Marshal General, Army of the Potomac.* Ed.: David S. Sparks. New York: Thomas Yoseloff, 1964.

Pullen, John. *The Twentieth Maine.* Reprint. Dayton, OH: Morningside Bookshop, 1994.

Schildt, John W. *Jackson and the Preachers.* Parsons, WV: McClain Printing Company, 1982.

Schildt, John W. *Hunter Holmes McGuire: Doctor in Gray.* Chewsville, MD: Privately printed, 1986.

Smith, James Power. *With Stonewall Jackson in the Army of Northern Virginia.* Reprint. Gaithersburg, MD: Zullo and Van Sickle Books, 1982.

Thomas, Dean S. *Cannons: An Introduction to Civil War Artillery.* Gettysburg, PA: Thomas Publications, 1985.

Varhola, Michael J. *Everyday Life During the Civil War: A Guide for Writers, Students and Historians (Everyday Life Series).* New York, NY: Writers Digest Books, 1999.

Von Borcke, Heros. *Memoirs of the Confederate War.* Reprint. Dayton, OH: Morningside, 1985.

Reflections

Whether we were to attack or repel, whether the fight was to be in the woods on our right in the ravine, or in the hills in our front, or on the crest amid the hostile batteries, I knew not, and then, when was the fight to begin? How long would it last? Who would win? Was I to be killed, to be torn with a shell, or pierced with a bullet? What was death? How quickly should I be in the other world if I were killed? I can venture to say that while we waited in the twilight, time flew with slow wings, and the quicker I was in it and through it, alive or dead, the better I thought I would be. This contemplating for a long time the black-muzzled cannon, and conjuring up the hosts who are to blaze at you with death-dealing musketry, is not pleasant.

— Thomas Livermore, 5th New Hampshire Infantry

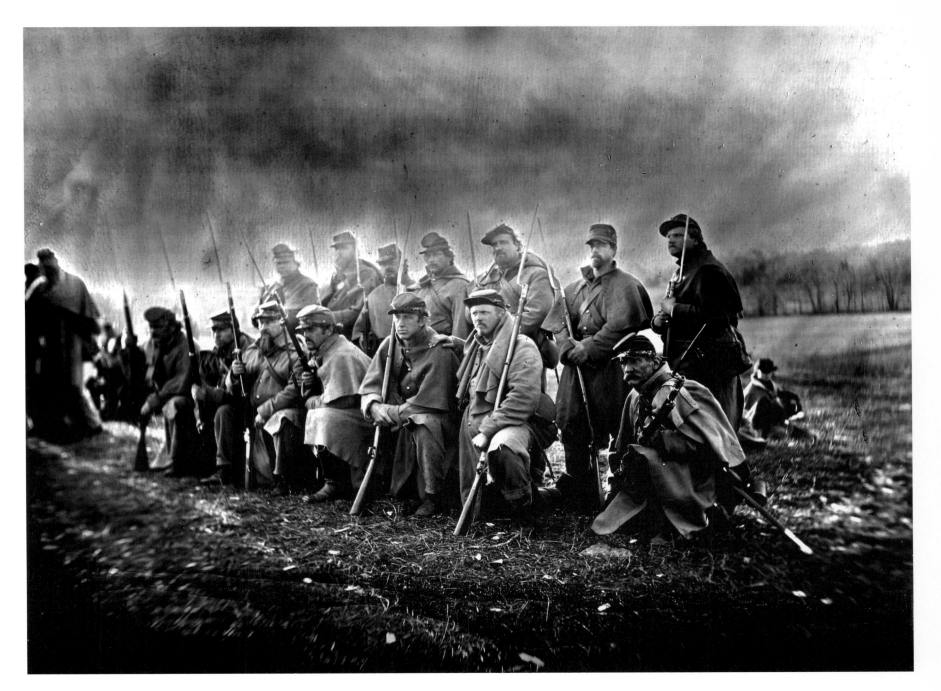

About the Authors

Rob Gibson

Rob Gibson is owner of Gibson's Photographic Gallery in Gettysburg, Pa. A recognized expert in the field, he has appeared in numerous documentaries on A&E, Discovery, The History Channel & PBS as well as a series of videos from Greystone Communications. His work has been featured in *Smithsonian Magazine, American Enterprise, Washingtonian, Shutterbug, View Camera, Range Finder, Popular Photography, American Profile Michigan Film Revue, Camp Chase Gazette* and *Battlefield Journal* and will also be seen in the upcoming film *Cold Mountain*. Gibson appears twice as a photographer in the movie *Gods and Generals*. Gibson has acted in a few independent films and was cast as John Wilkes Booth for the upcoming History Channel Production *April 1865*.

Dennis E. Frye

Dennis E. Frye, Associate Producer for the movie *Gods and Generals*, formerly served as Chief Historian at Harpers Ferry National Historical Park. He was a founder and president of the Association for the Preservation of Civil War Sites, Inc. (today's Civil War Preservation Trust), and co-founder and first president of the Save Historic Antietam Foundation, Inc. In addition to his preservation triumphs, Dennis has authored five books, written nearly 60 articles for Civil War periodicals and encyclopedias, is a popular lecturer, and is a busy battlefield guide for sites in Maryland and in the Shenandoah Valley. He and his wife Sylvia are restoring General Burnside's post-Antietam headquarters near the battlefield.

Thomas Publications publishes books about the American Colonial era, the Revolutionary War, the Civil War, and other important topics. For a complete list of titles, visit our website:
www.thomaspublications.com
Or write to:
THOMAS PUBLICATIONS
P.O. Box 3031
Gettysburg, PA 17325
800-840-6782

Gibson's Photographic Gallery is a fully operational wet plate studio with a complete wardrobe department. Photos from this book are available at the shop. Visit our website:
www.civilwarphotography.com
Or call us at 717-337-9393.

The National Center for Civil War Photography is a non-profit Pennsylvania corporation, whose mission it is to educate the public about Civil War photography and its role in the conflict; to preserve original Civil War photographs and equipment as well as original methods and techniques. Future plans include a permanent facility in Gettysburg. To become a member, call (813) 961-4131, or visit us at:
www.civilwarphotography.org